PARANORMAL
CUMBRIA

STEVE WATSON

AMBERLEY

Dedicated to my beautiful wife Angela.
Love you forever.

First published 2024

Amberley Publishing
The Hill, Stroud
Gloucestershire, GL5 4EP

www.amberley-books.com

British Library Cataloguing in Publication Data.
A catalogue record for this book is available from the British Library.

ISBN 978 1 3981 1875 1 (print)
ISBN 978 1 3981 1876 8 (ebook)

Typesetting by Hurix Digital, India.
Printed in Great Britain.

Contents

Introduction

I am extremely lucky to have travelled the length and breadth of the British Isles, both as a child and as an adult. From the glorious cliffs and coastlines of Northern Ireland, the breathtaking valleys of Wales, both the Highlands and Lowlands of Scotland, to the outstanding beauty of my homeland of Northumberland. However, I find it difficult for anything to compare to the peace and tranquillity of Cumbria and its Lake District. The rolling green mountains that are met by the deep blue waters of the lakes is quite stunning even today, after hundreds of visits.

My first experiences of 'The Lakes' were childhood trips in the car with my family during the 1970s and early 1980s. As a family I can remember going to the markets of Penrith and Keswick, and looking across to Dumfries and Galloway from the shores of Silloth. I remember tasting my first mint cake in Kendal, and paddling in the river at Pooley Bridge and on the shores of Ullswater, my Dad cursing as he had to constantly shift between first and second gear to get our car, a Rover estate, up Hardknott Pass, and my Mam's face when we all insisted on jumping aboard a boat to do a Lake Windermere cruise. But it was not just day trips; we also had holidays there.

We stayed in a farmhouse on the outskirts of Carlisle for a week in the summer of what I think was roughly 1977 or 1978 and I have three distinct memories of the holiday. The first was my brother breaking his arm after falling from a slide and my Dad rushing him off to the hospital. I don't know why this is so distinctive as it was a regular holiday pastime. 'Wor Dave' had the habit of breaking the same arm in the same place when on holiday. Actually, he is the only person I know of that could break his arm on the soft sands of Scarbrough beach – strange child! The second memory was of my sister Yvette's head getting used as a bird toilet. Although she will not be pleased with me sharing this, I still find it hysterical as she had really long hair at the time and for the mess it made, the bird must have been an albatross. The final memory I'll share from that holiday is of my Mam sending us across the lane in the morning to the farm to collect the fresh milk. I can still remember being fascinated that the jug was warm and the milk inside was warm as we poured it on our cornflakes, but most of all I remember the taste. It was nothing like what you buy in the shops; this was creamy, fresh, and tasted like ambrosia straight from the gods.

As I got older, I continued the tradition and took my wife and children on many trips and long weekends to Cumbria. Now the kids are older, my wife and I like to visit the area for a nice bit of quiet time. Also as a paranormal investigator with GHOSTnortheast for over a decade, I need no excuse for a good old-fashioned ghost hunt in the county.

Knowing the area very well, the opportunity to write a book about it was an easy decision to make. I was always fascinated that a county of such beauty can also look

quite foreboding and spooky as the sun goes down. The vast areas of countryside are blanketed with a sheet of pitch black with only the odd pin light of a farmhouse or hotel in the distance. The heavy grey outlines of the mountains towering over you could be the introductory scene of any good horror film. These incorporated with Cumbria's vast history has led me to hear many stories over the years. When I looked through my old notepads before writing this book, I discovered I literally have hundreds of tales of ghostly apparitions, poltergeists, demons, witches, imps, fairies and sea creatures; I even have tales of UFO sightings in the skies above. The county does seem to be awash with paranormal tales and it has been quite difficult to choose which ones to include.

As with all my books I have begun with a brief history and some quirky facts about the location. This hopefully gives you a background as to why the location might be experiencing paranormal activity. I could easily write about an old inn or big spooky house on a hill, but if the buildings have no history or context, it's hard to see why they would be haunted.

The stories I have included are a mixture of personal encounters from my investigations with my team at GHOSTnortheast, eye-witness accounts, folklore, and stories I have been told over the years. It always amazes me when I'm sitting in a pub or standing in a shop talking, and people ask me what I do. As soon as I tell them I organise public ghost hunts and write paranormal books they become very interested. The believers will go on to recount their experiences and their tales of the local area, while the sceptics will always say that 'they don't believe but let me just tell you this that happened to...' They then go on to recount their own ghost stories. I do listen intently, and these guys can share in some of the inspiration for this book.

Most of all, I do hope you enjoy reading this book as much as I have enjoyed writing it. After reading through the pages go and visit the locations and have a look for yourself. If nothing else, you will have a nice day out visiting some beautiful places. Are the stories true or are they just old wives' tales or made-up nonsense for a night around the camp fire? As always, I will let you decide.

My wife and I enjoying a break in The Lakes.

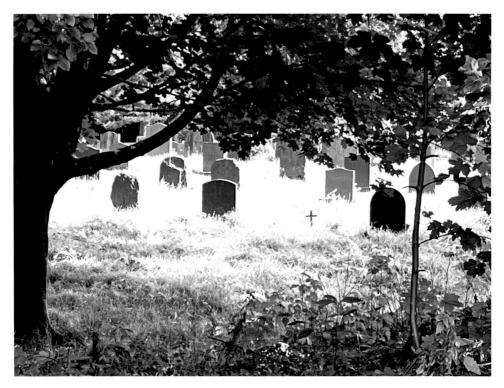

An old Cumbrian graveyard.

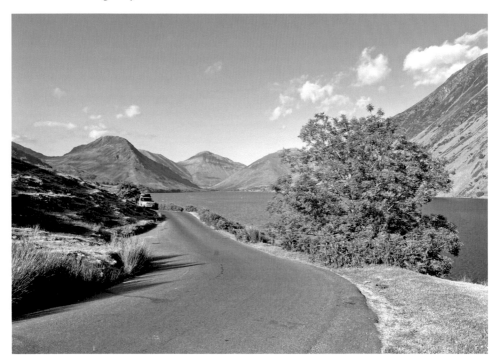

Typical Cumbrian landscape.

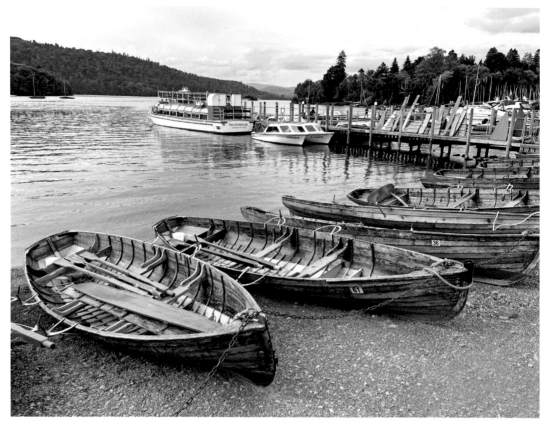

Boats by Lake Windermere.

Haunting landscapes.

Solway Aviation Museum, Carlisle

Carlisle Airport was built during 1941 at the height of the Second World War and was originally named RAF Crosby-on-Eden. A larger runway and buildings were built to replace the nearby RAF Kingstown, which was located on the outskirts of Carlisle. The new RAF base was used by Fighter Command to train pilots to fly Hawker Hurricanes, which were single-seat fighter planes. This was followed a year later, in 1942, by the arrival of the larger bombers. RAF Crosby-on-Eden would become the training centre for pilots of the Bristol Beauforts. The base would continue to support the Allies until the end of the war before being disbanded in 1946.

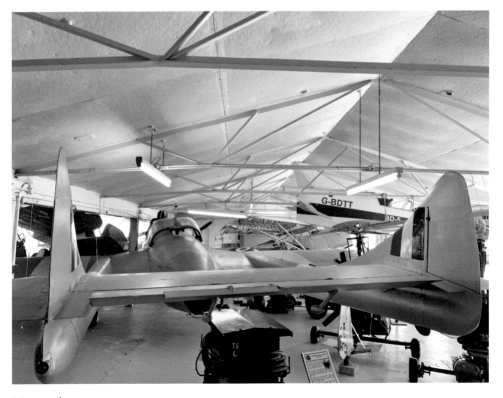

Museum hangar.

The airbase and runway were then handed to Carlisle County Council, who ran it as a municipal airport. Today it is called the Carlisle Lake District Airport and is the home of the Eddie Stobart Group. Their trucks have given my family a lot of fun on long boring drives as we always try and spot the girls' names on the front of the cab.

Located at the east end of the modern Carlisle Airport's runway are three buildings that are the remains of the RAF base and are surrounded by aeroplanes and various military vehicles. The complex is the home of the Solway Aviation Museum which has some extremely interesting exhibitions including the much-photographed Vulcan Bomber.

The museum opened in 1961 and over the past fifty years has been run by an extremely dedicated group of volunteers. They have built a museum full of interesting exhibitions that focus on the aviation history of Carlisle and the surrounding areas.

Building One is currently used as offices and a large hangar with numerous aeroplanes on display. Originally it was the kitchen, dining area and a hospital. Building Two is now the main museum with many exhibits including RAF uniforms and a reconstruction of an air-raid shelter. Building Three is the workshop. This is where the ingenious volunteers bring old aircraft back to life.

Outside is a car park surrounded by various post-war aeroplanes that all have their own stories to tell. They include a Lightning, Meteor, Phantom and Sea Prince.

With so much history in such a small space, it is no wonder that there are many tales of ghosts and paranormal activity. However, the first time I was made aware of the museum was upon hearing tales of the sightings of Roman soldiers in the area. Some people have reported seeing a solitary soldier walking across the field near to the runway. Other reports are of up to a dozen soldiers marching, before disappearing into the bushes and trees.

This would make sense as the land between Carlisle and Brampton is synonymous with Hadrian's Wall and the airport is close to the old Stanegate Roman road that actually predates the wall. It is also believed that a Roman fort was located in Crosby, a small village near to the airport.

Reports of apparitions and poltergeist activity are rife within the buildings. Unexplained noises and voices have been reported by both guests and staff over the decades that the museum has been open. I was fortunate enough to conduct a paranormal investigation in the museum with my team from GHOSTnortheast and I must admit to hearing and seeing things I could not give any rational explanation for.

In Building One, a man was spotted by numerous people walking around the top of the display area. The people said that they had seen a man walk from one side of the room to the other. They checked with everyone in the building, and no one was in the area at this time. I also pointed out that the door was on the other side of the room; therefore they would have had to have seen him arrive and leave due to the location of the door. I and the others that were in the room have no explanation as to who the man was, where he came from or where he went.

In Building Two the group were sitting in the model air-raid shelter using various pieces of equipment when footsteps were heard outside in the museum. They were expecting someone to arrive, but no one appeared. As they were calling out to see who was there, children's laughter was heard by all of the group. However, this was to take a darker turn as one of the group reported that they could see a black figure that looked like it was on all fours moving around outside of the shelter. One person

Corridor where footsteps are heard.

said they thought it looked like a large dog. As they said this the whole group gave out a yell as a loud growling noise was heard. The reports of ghostly dogs being seen in this area were confirmed by the museum staff and have been recorded for years.

The Solway Aviation Museum is a cosy, friendly attraction during the day with much to see and do, but when night falls and the public leave, the buildings seem to want to tell their stories, and the past personnel want you to know they are there.

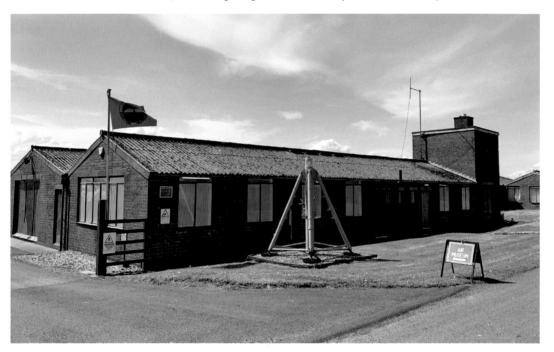

The Solway Aviation Museum.

Wicked Jimmy of Lowther Castle, Penrith

As you approach Lowther Castle you are in awe at the size and grandeur of the building. You can only imagine how breathtaking it must have been before the decay set in, reducing large parts of it to ruins. Today, the Lowther Estate Trust has done a tremendous job of stopping the rot and rebuilding large parts of the estate to its former glory so that the public can visit this historic part of Cumbria.

Lowther dates back to the middle of the twelfth century. The land was owned by Dolfin de Lowther, a descendant of Viking settlers. It is believed he gave the place its name from the word 'lauthr', which is Norse for 'foaming water', and it is said to have been inspired by the river it stands upon.

Over the following one thousand years, the Lowther estate would be full of colourful characters as the family would be granted the title of earl and countess of Lonsdale. History shows us that sometimes money and titles cannot guarantee love, happiness or health.

The first seven hundred years would see a number of manor houses and halls built and destroyed on the land. However, it is in the middle of the eighteenth century when the family become extremely interesting with the introduction of James Lowther, who inherited Lowther Hall and its estate from Henry Lowther, who was his great-uncle.

James became well-known for his terrible temper and nastiness, especially towards his servants and employees. He would let people know that he hated his wife and never wanted to marry the woman. Obviously, this in turn made his wife hate him and question his sanity. He was an eccentric man and would dress in Georgian-era clothing and would have preferred to live in this time period as he detested the way the world was changing.

He had several mistresses during his married life and made no secret of his extra-marital affairs. However, one particular mistress would lead to probably one of the most horrific stories of Lowther Castle. James fell in love with the daughter of one of his farm tenants. He moved her into the hall and treated her to all the luxuries of being the mistress to an earl. It's said that the only time he smiled was when she was in the room, and she was the only person on earth that had a nice word to say about James. Unfortunately, she died before him, and he could not come to terms with her death. He kept her corpse in his bed for weeks before the smell and the natural decomposition forced him to move her body. He then placed her body in a coffin with a glass lid. Some stories say that he then made his servants move her around the house

and join him in rooms as if she were still alive, and some stories say she was put in a cupboard in his bedroom so he could visit her whenever he felt the need.

Eventually, the body of the poor lady was buried in London and James disappeared. People believed he had actually moved into the crypt to be with her. During his later years when he returned to Lowther, his behaviour was becoming increasingly bizarre, which led the locals and his staff to give him the nickname 'Wicked Jimmy'.

He was convinced that he could cheat death and spent most of his time and a lot of his money on harebrained schemes to escape the inevitable. In 1802, he died of natural causes and as he had no children, the estate was passed to his cousin William Lowther.

William Lowther and his wife Augusta built the Lowther Castle we see today. Work began on William's dream home in 1806 and took eight years to complete. He would live in the castle until his death in 1844. The castle would become well known to the arts and culture community, as both William and Augusta would become friends of poets and artists, most notably William Wordsworth and J. M. W. Turner.

The castle passed through the family until 1882 when it was inherited by Hugh Lowther, the 5th Earl of Lonsdale. Even when Hugh inherited the castle at the age of twenty-five, his lifestyle was already controversial, as he had dropped out of his Eton education and married Lady Grace Gordon. The Gordon family didn't approve of the marriage as they didn't deem Hugh either rich or educated enough to marry their daughter.

Over the years, Hugh's extravagant lifestyle and love of spending money saw him racking up huge debts, which resulted in him having to sell off his assets. He would be the last Lowther to live in the castle as he left in 1935, when he could no longer afford to live in his ancestral home. He passed away in 1944.

The castle would spend the next few decades in decline. The roof was removed to avoid taxes and the interiors were stripped to raise money to pay off the debts that were left on the estate. Thankfully in 2011, the Lowther family returned to the estate and invested over £9 million in a restoration project that would take five years to complete. Finally, in 2016 the castle opened to the public and is now thriving as a successful tourist attraction in the heart of Cumbria.

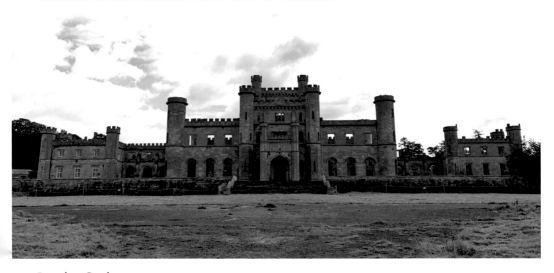

Lowther Castle.

As you can see, with so much history and so many characters having walked the estate, it comes as no surprise that there are a lot of ghost stories surrounding Lowther Castle and its gardens. There are reports of children in Victorian dress being seen in the gardens and throughout the buildings. People have seen and heard people working in the stables, which have now been converted into storage and public toilets.

Some the most repeated reports are the sounds of parties coming from the hall area. Today the hall has no roof and is only a shell of the building, but both staff and guests have reported hearing music and chatter coming from this area, only for no one to be present when they have entered the area.

A large, very well-dressed man is often seen in the vicinity. Complete in a three-piece suit and yellow tie, he has been reported to be sitting in the middle of this area laughing loudly. He will often nod his head at visitors, before returning to talking to someone who is not there. It is believed to be Hugh Lowther still enjoying his lavish lifestyle from beyond the grave.

The various countesses have been seen walking the grounds, and the castle is home of a 'Grey Lady' and a 'White Lady' – whether they are the same person, no one knows. However, along with the sightings of the 'Grey Lady' are reports of a putrid smell often described as rotten meat, which leads us to believe it could be the wandering corpse of Wicked Jimmy's mistress still searching for peace.

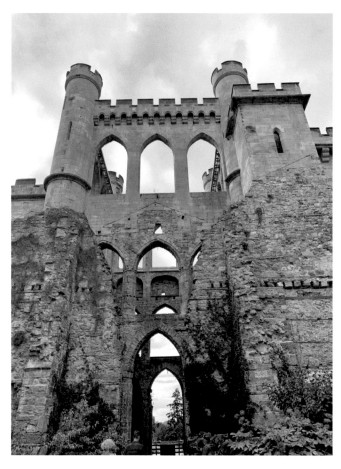

Ruins of the old castle.

This links to the final ghost story I shall tell, and that is of the ghost of 'Wicked Jimmy' himself. Jimmy's ghost is still said to wander the estate and the castle buildings. There have been many reports of women feeling as if they have been touched, pushed or just a general feeling of unease. After this activity a small gentleman is spotted in the area dressed in unusual Georgian-era clothing. When the visitors have been shown the portrait of 'Wicked Jimmy', they have all confirmed this is indeed the man that they have seen.

His ghost has even terrorised the local area, being spotted in the back lanes and farm tracks around Penrith riding on horseback or riding on top of his black carriage. It is said that it sends the local cattle and farm animals into a panic, causing trouble and damage for the local farmers to deal with. Maybe Jimmy still blames the locals for the death of his one true love.

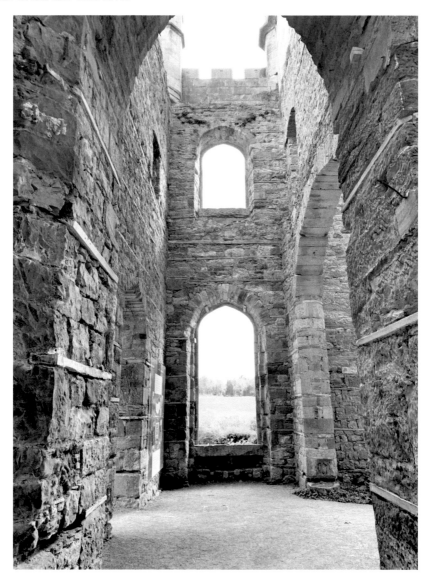

Inside the older part of the castle.

Furness Abbey, Barrow-on-Furness

Situated on the outskirts of Barrow are the most magnificent ruins of a twelfth-century abbey. Furness Abbey, also known as St Mary's of Furness, dates back to 1123 and when it was built it was the most powerful and richest Cistercian monastery in the country after the neighbouring Fountains Abbey in Ripon, North Yorkshire. The monastery and abbey was built with the blessing of King Stephen.

Over the centuries that followed, the abbey and the monks who lived there enjoyed great wealth and power in the region. The surrounding land was rich with natural minerals, and was very fertile and ideal for farming and rearing sheep. The sheep led to a great resource of wool, which was ample enough to sell. The Cistercian monks enjoyed a happy life with the lands around the abbey thriving until 1537.

In 1534, Henry VIII passed the Act of Supremacy, which made him the Head of the Church of England. Over the following five years he would strip almost all of the 625 monasteries in the country of all their power and wealth. Furness Abbey was not to escape the Act and in April 1537 a deed of surrender was signed by the abbey's abbot and the fate of the buildings were sealed. While some of the monks stayed behind, the majority fled the abbey, and King Henry's men destroyed the buildings. The abbey would've been stripped of anything of worth including any relics inside and the lead on the roof. Without any support or money, the buildings became ruinous and fell apart.

Over the following centuries the land and the abbey ruins would change hands between local families and probably due to the vast amounts of money it would take to repair, the abbey stayed as a ruin. However, the abbey enjoyed a revival in Victorian times when it is mentioned several times in stories and poems. Famous visitors in the nineteenth century included the artist J. M. W. Turner, William Wordsworth and Queen Victoria, who was said to be overwhelmed by what she saw. The abbey's manor house was redesigned and in 1947 was officially opened as the Furness Abbey Hotel.

In 1923, the abbey and its buildings were put into state care by the landowner, Lord Richard Cavendish, as the ruins had started to collapse. Unfortunately, the hotel was demolished in 1953 after the building had sustained damage by bombing in the Second World War.

Today the site is cared for by English Heritage, who have gone to great lengths to strengthen the ruins, and they have built a visitor centre on the land where the hotel once stood proud to create an excellent tourist attraction once again.

When researching ghost stories and tales of paranormal around this location I was well aware that the majority of them would include sightings of monks or hooded figures. What I wasn't prepared for was the number of stories that described these monks as wearing white robes. Most stories I am told about sightings of ghostly monks usually involve them wearing brown gowns or dark clothing. This left me to research the abbey, and its abbots were indeed known to wear white robes. The figures have been reported many, many times around all areas of the grounds and at various times both through the day and at night. The remains of the stone staircase seem to be a hotspot, with reports from people seeing the monks going up and down steps that are no longer there. Another story of a ghostly monk recalls that of a figure that wanders around the grounds with a walking stick that shines at the top. Some reports said that it resembled a shepherd's crook. The monk appears at the east end of the church then disappears through the walls to the west. Later reports have him appearing at the east end of the church before walking across the site towards the visitor centre, where he disappears. Could this be the abbot whose skeleton was discovered during an excavation and was found with his ring and crozier. Is the shiny walking stick the glinting of the gold of the crozier that is now displayed in the visitor centre?

I couldn't leave Furness Abbey without mentioning the story of 'The White Lady'. The spirit of a lady dressed in white has been reported many times with some witnesses saying that she has actually interacted with visitors to the site. She is often spotted by the bell tower or walking around the walls of the abbey. No one seems to know who this ghost is or why she is haunting the area. Some say she guards the treasures that still lie below the abbey, some say she's a local girl searching for her lover, and some say she died in mysterious circumstances in the hotel. Unfortunately, I could find no explanation as to who she could be, so if you bump into her on a visit to the abbey, make sure to ask who she is.

The Village of Boot

Nestled in the valley of Eskdale is the picturesque village of Boot. Accessible from the Hardknott Pass, Wrynose Pass, or on the scenic steam railway that runs from Ravenglass, this hidden gem of Cumbria is steeped in ghost stories and sightings. We know that a church was first erected in the sixth century at Boot and was where St Catherine's Church sits now. St Catherine's itself dates back to 1125 with further building work taking place during the fourteenth century. It's restoration, the results of which we see today, was carried out in the early 1880s and has survived centuries of harsh weather. However, the two ghost stories that revolve around the church are both not actually connected to the building. The first is the sightings of the ghostly funerals that have been spotted, usually reported early in the mornings and when the weather is grim. People have reported seeing a funeral march walking down towards the church. When they follow it down the lane, the procession simply vanishes into the churchyard. One witness told me that when he was out rambling, he was starting early as possible, and it was not long after dawn. It was a misty morning with the rain drizzling down as he walked through the village, and as he passed the lane he looked down and saw a small group of people walking down behind a coffin that was being pulled by a horse. He said that he stopped to watch as it made its way to church and was fascinated that they were using a horse and cart in this day and age. He lost sight of the funeral as it turned the corner and decided to walk down behind the procession at a distance as he needed to cross the river near to the church. As he walked past the churchyard entrance there was no one around. He then walked through the graveyard to see where they had gone, but again there was no one to be seen. He spent all day on his walk around the hills questioning what he had seen and still to this day has no answer. Aptly, the lane where he had seen the funeral is Aptly, called the Corpse Road. The 'corpse roads' in Cumbria are a set of roads that were used to connect small villages where the locals would carry their dead to be buried as not all the villages had a church. The corpse road in Boot runs 6 miles across the fells to Wasdale Head. When I explained this to our witness, he was firstly surprised but then said it made sense as to the horse and cart and the way the people were dressed. He has not walked the corpse roads since.

The second story in this area of Boot is of a local character called Thomas 'Tommy' Dobson. Tommy was famous throughout the Lake District as a huntsman. Renowned for his sport with horses and hounds, he is celebrated with a fine gravestone in the graveyard of St Catherine's Church where he was buried in 1910 after dying from pneumonia aged eighty-five. His body was transported by horse and cart along the Hardknott Pass to Boot where he was laid to rest. However, his spirit is still spotted

throughout Eskdale from Wasdale Head to Boot, including reports on Scafell Pike. In the reports he is either heard or seen. One couple reported that they were walking along Hardknott Pass towards Boot when they heard the blast of a trumpet or a horn. They could hear the clatter of horses' hooves and the yapping of dogs coming from behind them. They moved to the side of the road to let the party pass by, but as they turned around they could see nothing approaching. They both swore that they had heard the commotion and could not explain what had just happened. The exact same tales have been told throughout the area, and it is believed that Tommy is still out there enjoying his hunts.

Another historic building in Boot is at the opposite side of the village. The Eskdale Mill is a Grade II listed building that dates back to least 1737. Records show that an original mill has been on the site since the thirteenth century. The waterwheel is powered from the water that runs down Whillan Beck. In days gone by, the wheel would power the mills' grinding stones and today's museum has a fascinating insight into an industry of yesteryear. Today it is connected to the National Grid and feeds electricity into the system for us all to share. The mill is also surrounded by a number of buildings, but the ghost story I've been told takes place up the hill where the beck starts to fall. There have been reports of a small boy who sits with his legs crossed and stares down the beck toward the mill. He is supposedly wearing shorts and a cloth cap, suggesting he is from the Victorian era. When he is approached, he neither looks up nor acknowledges that someone is talking to him; he just continues to stare down towards the beck. We have no idea who he is or why he sits here, but he disappears from view as fast as he appears.

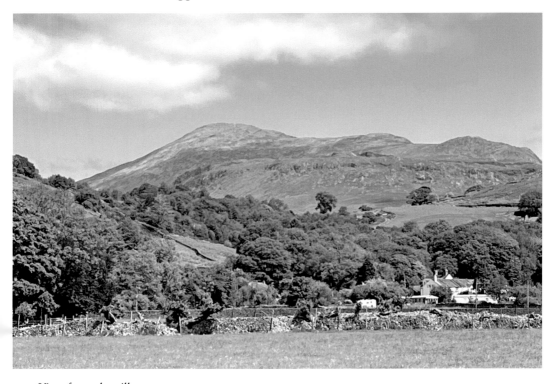

View from the village.

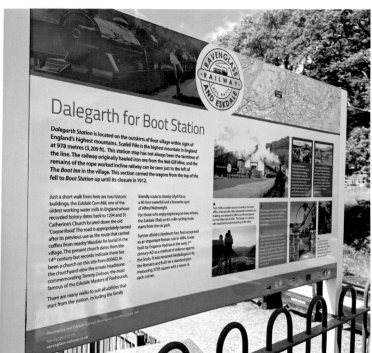

Dalegarth station.

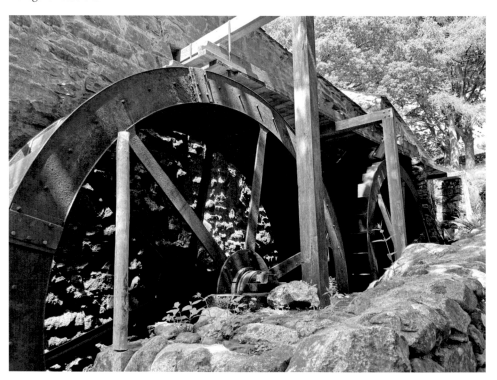

Waterwheels.

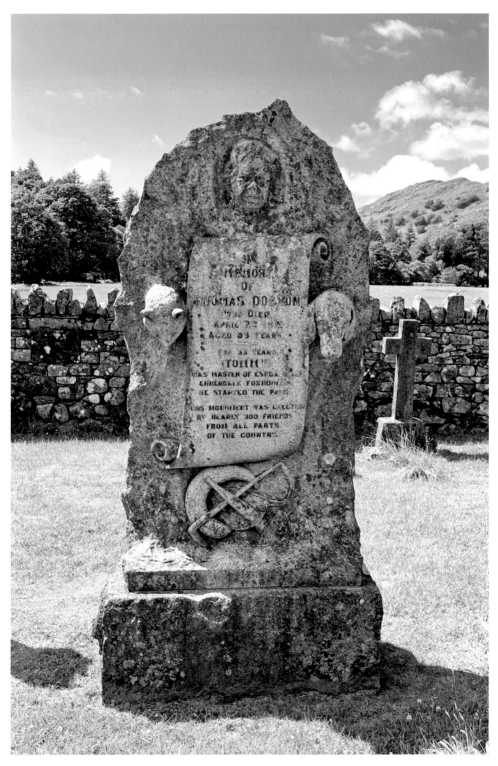

Tommy's gravestone.

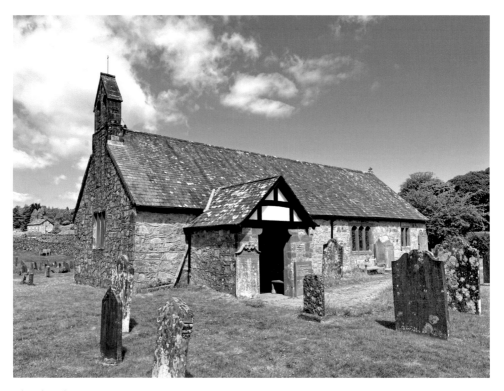

The church at Boot.

The old Corpse Road.

Muncaster Castle and Ravenglass

Sitting proudly above the River Esk, Muncaster Castle has all the history needed for a good haunting and claims to be one of the most haunted castles in world. To find the origins of the castle's vast history, we start a mile down the road at the small village of Ravenglass, nearly 2,000 years ago. The Romans had arrived in England and soon built a vicus (a large settlement) on the coastline at Ravenglass in approximately AD 120. This settlement would grow in size to become a major port and trading route in Cumbria, supplying the forts in Hard Knot and Ambleside for next three centuries. Today, Ravenglass is a hub for tourism. Its Roman remains are still a key focus with its famous bath house still standing. It is also home to the Ravenglass to Eskdale Steam Railway. The connection between the railway and the Romans leads me on to a ghost story I was told by a visitor to the area. Obviously, with so many links to the Romans, the number of reports of ghostly soldiers walking in and around the village are vast and date back decades, if not centuries. However, the story I was told was when the visitor was sitting on the train returning from Dalegarth and was approaching Ravenglass station, coming to the end of his journey. He explained it was a sunny summer's day in the Lakes and he could see for miles across the fields and hills beyond. He and wife were visiting the area on holiday, and he was taking in the landscape when in the distance he could see a large group of men walking across one of the fields. He said that he stared at them for a good few minutes before realising they looked like Roman soldiers all walking in perfect time with one another.

He said: 'I sat and watched for a while thinking "what are they doing out there?" For some reason I thought they looked how you would typically imagine a Roman soldier to be dressed. I turned to my wife, pointed at them, and said they must be filming a TV show or doing a re-enactment. She said she couldn't see anything. Again, I pointed to the field where I could see them. Again, she said she couldn't see anything as the sun was in her eyes. The third time I turned around I had lost sight of them. When we left the train, I asked if anyone knew of anything happening in the area, but no one was aware of anything that would match the description. When we got back to the hotel, I checked the internet for any local events but to no avail. I think at first my wife thought I was making it up until she realised how rattled I was when I became aware I was the only one who had seen them.'

I asked him if he believed he had seen one of the legendary ghostly Roman legions making their way up to Hard Knott and beyond? He replied, 'Well I have no other explanation and I used to tell people I didn't believe in ghosts.'

Moving on to Muncaster Castle. It is believed that it is built upon a Roman settlement linked to Ravenglass. During an excavation, Roman coins and other paraphernalia were discovered at the site. It is believed that part of the castle is built on the solid foundations of previous Roman buildings. This does seem feasible as the settlement was only a mile away. However, the estate first appears in the history books in 1208 when the land was granted to Alan de Penitone by King John. The castle was first built later in that century, with a pele tower added the next year. The castle and estate stayed within the family as it was passed through the generations. In the middle of the nineteenth century, the family decided to renovate the buildings, adding a library and bringing the castle up to standard, with the great hall and tower being the only original parts of the castle that were left untouched.

Today, Muncaster Castle is still owned by the Pennington family, and they can boast that the building has housed 800 years of their history, and within that history there are so many interesting stories to tell.

The term 'tomfoolery' is believed to originate at Muncaster Castle. Every castle in the Middle Ages would employ a court jester, otherwise known as a fool. Muncaster was no different. In the sixteenth century they appointed their first jester, called Thomas Skelton, who became known as Tom the Fool and was famous in the area for his entertaining stupidity that quickly became known as his 'tomfoolery'. However, it is also said that Thomas had a darker side, and it was rumoured that he was involved in the murder of one of the castle's staff. The story is that the daughter of Sir Pennington of Muncaster fell in love with a local carpenter and planned to elope with the young man as her father had betrothed her to a member of the local gentry. The Sir she was betrothed to had heard of her plans to elope and went to the castle to challenge her father and ask if he had knowledge of the illicit affair, at which point he happened to cross paths with Thomas Skelton. After a conversation between the two men, it became apparent that Thomas had a dislike of the carpenter as he believed he had stolen money from him. In an instant a deal was done: if Thomas killed the carpenter the Sir would ensure that he would protect him and that he would face no punishment for the crime. Later that evening Thomas sneaked into the carpenter's shed and in one fell swoop chopped off the young man's head with an axe. When the murderous deed was discovered, the Sir kept his word and Thomas was never punished.

Tom the Fool and his antics have been reported over the years in many ghost stories and sightings. The castle has had many reports of a young lady that roams the castle and the grounds of the estate. She is described as young and beautiful but always crying. It is believed that this is the daughter involved in the above story still looking for her one true love whom Tom had taken away from her. A headless man is also spotted around the stables and work sheds. Again, this is believed to be the carpenter; whether he is searching for Tom for revenge or his future wife or indeed his head is anyone's guess.

Thomas himself has been spotted in the grounds sitting under a tree that has been named after him. He is rarely seen in the castle itself; however, staff and guests often report practical jokes being played on them with no one taking ownership for the pranks. This is believed to be Tom still getting up to mischief. Overall Muncaster Castle does seem to be one of the most haunted, but I will let you decide.

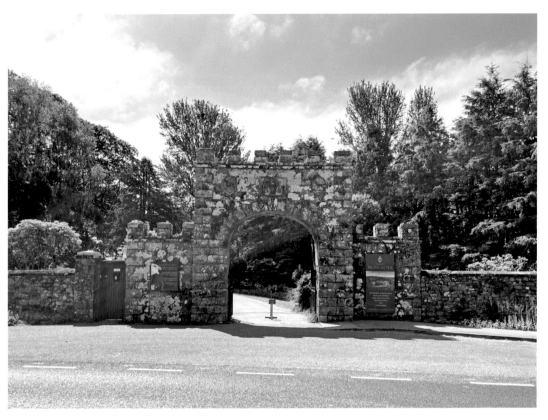

The gatehouse.

Under a tree.

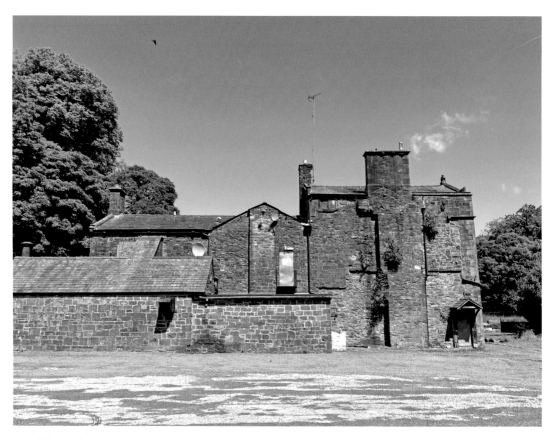

The castle.

Dacre Hall, Lanercost Priory

On the outskirts of Brampton as you drive west, you will cross a small bridge and come upon the picturesque little village of Lanercost. As you continue around the corner and through the village you will stumble across its preserved priory and grounds. The priory dates back to the middle of the twelfth century and is surrounded by its own graveyard, whilst opposite are a number of buildings that were built to support the priory throughout its rich history including a manse that is still in use today.

It was the vision of Robert de Vaux in 1165 to have a building for Augustian canons to work from, and by the end of the decade the priory was built and fully functioning. It was unusual in the way it picked its lord prior as he left it to the canons to choose their own, by election with a majority rule, much like how the Pope has been chosen by the Catholic Church. Little did Robert know then that the priory would have a long and eventful life.

As it stands close to the Scottish Borders the priory has suffered numerous raids from the Scots with accounts dating as far back as 1296, when it is reported that after the border raiders had taken up residence in the priory, the king had to send troops up to Lanercost and the Scots fled the area, running off through Nichol Forest and back north to safety. Even Robert the Bruce decided he wanted a piece of Lanercost as he raided the village and then the priory in 1311. It is reported that he spent three days committing an 'infinite of evils' before he retreated when the English armies arrived. However, Lanercost Priory was probably better known back in those dark days for its royal visits. It had been visited by many monarchs but none as often as King Edward I. The monarch was known to stop at Lanercost whenever he was up in the north, but his visit in 1306 would turn from an honour to a scandal for the canons, causing a stir that eventually involved the Vatican.

King Edward was in ill health and travelling through Cumbria when his condition deteriorated rapidly. A return home was out of the question, so he diverted to Lanercost and settled in the priory for over six months. During this time the area became encamped with the tents and settlements of a royal entourage, with the country being run from the west wing of the priory that would become Dacre Hall. The king recovered and was deemed fit enough to travel in the spring of 1307 and journeyed back to London. However, his visit had decimated the local supplies and the canons of the priory had very little left to distribute to the local surrounding area. The canons and lord prior had asked the king on several occasions if they could be recompensed for the visit, but the requests fell on deaf ears. The lord prior thought this to be an injustice to their hospitality and contacted his counterparts in Italy, who in turn spoke to the king directly. The king eventually agreed by granting them the earnings of two nearby churches and never visited Lanercost again.

The priory continued to flourish over the following centuries and became quite an affluent parish, only hampered by the occasional raid by the Scots. However, in 1538 King Henry VIII dissolved all monasteries in England and Lanercost was no exception. The canons were ejected from the buildings with many killed at the hands of the king's men as they ransacked the property, taking anything of worth including the roof. The estate was then given to the Dacre family, who owned it before it was handed over to the Howards in the eighteenth century. As part of the roof in the west wing was left intact the local villagers used the building as their church. The roof was replaced in 1737 and the structure continued to be used as the local place of worship but collapsed only a century later in 1837. The building became ruinous as the costs of maintenance and repairs became too much and finally in 1929 it was handed over to public ownership. Today English Heritage have restored it.

The ghost stories surrounding the priory are many and mostly what you would expect, just like Furness Abbey, mentioned in an earlier chapter. Many sightings involve monks or hooded figures seen wandering around the grounds and inside the ruins itself. There have been many reports of chanting being heard echoing through the ruins and white shapes moving around the graveyard. There have also been sightings of men running across the field into the trees and towards edge of the grounds. It is said that you can hear them shrieking and calling out as they disappear into the line of trees. Could this be the Scots taking flight at the thought of being caught by the English army and sent to their execution? Most of the more personal and scary stories seem to revolve around the east wing of the priory that is known as Dacre Hall, which I have been lucky enough to visit after dark.

In 1542 after the dissolution by Henry VIII, the priory and its estate excluding the part of the priory being used as the church and graveyard was given to Thomas Dacre. Thomas decided to turn the east wing, which included the cloisters, into his home. He redesigned the building and converted the upstairs into a long banqueting hall and extended the building onto the newly refurbished Dacre Tower that had been left to rot since medieval times, creating a large and impressive home that he named after his family. Over the centuries as the priory changed hands, so did the hall but the name was kept. In 1952, the hall was given to the village of Lanercost and has belonged in their care ever since, making it quite possibly the oldest village hall in the country if not the world.

Paranormal activity has been reported throughout the hall and both floors. There have been numerous reports of laughing and singing from the hall when no one is in the building. Dark, hooded figures are seen moving around the building in the dead of night. Electrical equipment has behaved unusually with lights switching on and off for no reason. The doors have been heard slamming shut when they were closed already along with loud knocking or banging coming from behind the same doors only for no one to be there upon investigation.

One of my personal experiences was very unusual and has still not been explained. We were with a group of guests in the kitchen area when they reported hearing a series of footsteps. They described them as sounding like someone running up and down some stairs, but they were confused as there were no stairs in the room. When they heard them again, I asked them if they could be more specific to the area where the noise was originating from. They all pointed toward the locked door at the back of the room. They told me in sounded like it was coming from the cupboard. These

noises were also repeated with a second group of guests, and I can verify both groups of people were unconnected and had no knowledge of what the others had reported. When we opened the door and they discovered that 'the cupboard' was in fact the old unused stairway to Dacre Tower, the groups were staggered as they could see that nobody could have been in the staircase, and nobody was aware that there was a staircase in the room.

Wastwater and Wasdale Valley

Wastwater is the deepest lake in England and is a 3-mile stretch of water in the western shadow of Scafell Pike (the highest peak in England). The rivers that run into the lake cut through the mountain range, creating a natural valley. The lake has several small villages near its shores with some very interesting ghost stories. But first I will start with the stories of the lake itself. As with most lakes in the UK it has reports of a 'Lady of the Lake'. The stories say that a beautiful woman stands on its shores enticing people into the lake to swim with her. The victims then find themselves out of their depth and unfortunately perish as the lady claims another soul for the lake. As spooky as it sounds, I think this may be a story told around a campfire or even folklore as I cannot find any evidence of these deaths. I was told that it revolves around the true story of Margaret Hogg. In 1976, she was murdered by her husband, who then disposed of her body in the lake. She was not found until eight years later. However, the stories of the beautiful siren that claims the souls of so many has been told for centuries and well before Margaret met her unfortunate and untimely death.

At the northern point of the lake is the very small village of Wasdale Head. The village can boast being the home of Scafell Pike and is the starting point for many hikers who want to climb to the peak. And it is many of these hikers who report of being given false information about the surrounding area by an elderly gentleman. One of the stories that I have been told is that of a hiker who had been warned not to climb the hills on a particular day as there had been sightings of a family of fierce wild cats that were deemed dangerous. When the hiker returned to his hostel to await news the people there started laughing at him, mocking him for delaying his walk. Once they ensured that the story was not true, they asked him where on earth he had been given such information. The hiker told him that the old bloke outside the pub had told him. Another pair of hikers also told of receiving a warning from an elderly gentleman outside the pub. They said that they were having a drink before beginning their walk when he warned them about the dogs with wings. When they asked what he was talking about, the gentleman told them that people had complained that when they got to the top of the pike they were attacked by what looked like a cross between a dog and an eagle. The hikers laughed it off and thought that the man was just a local character who had had one too many. However, when they were inside, the staff member described the elderly gentleman and the hikers agreed that it sounded like him. They went white with shock to learn that the man died 100 years ago. This man is believed to be Will Kitson, the landlord of the pub during the 1800s who proclaimed himself as the 'World's Biggest Liar' as he entertained the locals with his

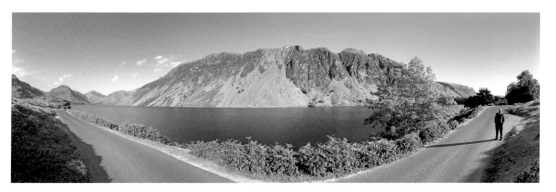

Wastwater.

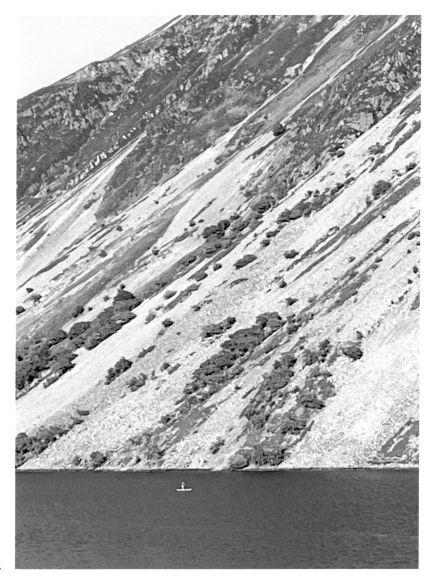

The mountains
meeting the lake.

tall tales. If you visit Wasdale Head, not only do you have a chance of bumping into Will, but it is also the start of the Corpse Road that travels to Eskdale, so you may also see the odd ghostly funeral march.

At the south end of Wastwater is another small village called Nether Wasdale. I visited this village out of intrigue after being told a very interesting story by a person who had been staying in the area on a short break. The person in question is a sceptic of all things paranormal, which made the tale all the more intriguing. He said that he was in the village walking past the old church when he saw a young boy and a young girl playing in the graveyard. He said that he probably would have taken no notice of them but for the way they were dressed. He described them as wearing Victorian-style school uniform. He pointed them out to his wife, and she commented on the little boy's cap and shorts. They then heard a bell ring and the children disappeared towards the school hall. Still wondering about the pair, he walked up to the building as there were no lights on and peered inside. The building was completely empty and was no longer used as a school. In fact it hadn't been used as a school for decades. He had no explanation for what he saw and said it was even more unsettling as his wife had seen the exact same thing. I am not so sure he is such a sceptic anymore.

Nether Wasdale.

Nether Wasdale graveyard.

Nether Wasdale old school hall.

Piel Island

Piel Island is located on the southern tip of the mainland of Furness near Barrow. The island stands proud in Morecambe Bay and is home to a castle, cottages, The Ship Inn, and a thousand years of fascinating history. It is only accessible by foot at low tide by those with exceptional local knowledge. Without this knowledge it can be treacherous as most of the surrounding area is quicksand and the tides can be unforgiving. Therefore, I'd recommend using the small ferry service that runs from the neighbouring Roa Island and keep your feet dry.

Life on the island probably dates back to Roman or Viking times but it is not until the twelfth century that we see the first mention of note of its inhabitants, when the island was known as Fouldrey. In 1127 King Stephen granted the island to the Savignac monks, probably with the intention of them using the island for a monastery. However, over the years the monks realised it was the ideal place to store supplies without the fear that they would be ransacked or pilfered. The monks later joined the Cistercian monks of nearby Furness Abbey and the island's ownership was signed over. The Cistercian monks continued to use the island for storage and in the early fourteenth century they fortified their facilities by building a wooden peel tower. The island's storage became important to the abbey because they found it to be an ideal way to smuggle contraband without paying tax to the Crown and this would start nearly 700 years of the island being infamous for its smuggling trade, to such an extent that the Crown would house customs men on the island. Over the centuries that followed the wooden peel tower was strengthened and built with stone as the island continued to be vital throughout the Middle Ages. After the dissolution in 1537, the island fell into the hands of the Crown and was used for naval purposes until 1662, when the estate of Piel was given to George Monck, the 1st Duke of Albemarle, by King Charles II as a reward for his support during the restoration of the king. The stories of the island seem to go cold at this point until a mention in 1875 when the island was owned by Walter Scott, a Scottish politician and the 5th Duke of Buccleuch. Walter oversaw the building of the fisherman's cottages that can be still seen on the shore of the island today. In 1920, Walter's grandson John Scott donated the island to the people of Barrow-in-Furness.

The other building on the island is the public house called The Ship Inn. The age of the pub seems to be open to debate, with some dating it back to the middle of the eighteenth century and others the nineteenth century. Either way, what is not open to debate is that the landlord of the inn is 'The King of Piel'. When a new landlord is appointed to the pub, a ceremony is carried out and the new island king is announced. The king, amongst other duties, can appoint knights. To be a 'Knight of Piel', you have to sit on the throne wearing a hat and holding a sword whilst having beer poured over

your head in the same ceremony as the king. However, you must also buy a round of drinks for everyone in the inn at the time and your knighthood is only appointed by the king or another knight.

The other interesting fact of the island that is up for debate is its name. One theory is that the original castle was a large peel tower, and the word 'peel' has changed to 'Piel' over the years. Another theory is that in 1423, at the height of the monastery smuggling, the monks were selling wool from the island without paying the tax, and the Abbot of Furness was charged for what became known as his 'Pile of Fouldrey'. Hence 'pile' became 'Piel'.

The ghost stories on Piel Island are many, and seem to cover all the major events throughout its colourful history. We have reports of Roman soldiers, Vikings, and Scottish raiders. We have numerous sightings of monks wandering around the island. An abbot is said to stand high up in the castle ruins and shines a lantern on stormy nights to warn boats to prevent them becoming shipwrecked. A more recent report is that a barman of The Ship Inn was convinced that a small dog was a paranormal resident in the bar. Unfortunately, when I visited, I could not find the barman, so cannot retell any of the dog stories. But the most spine-chilling story I have heard dates back to the 1960s and in good ghost story-telling tradition started one stormy winter's eve.

It was a cold night and the storms had arrived from the west, travelling over the Irish Sea into the bay. The island was taking a battering. The pub was empty as there had been no visitors from the mainland due to the bad weather. The barman at the time was taking advantage of the pub being closed and doing a deep clean of the bar area when there was loud knocking on the front door. Surprised at the prospect of someone visiting, he opened the door to find a man stood outside soaked through to the skin and shaking. The barman quickly ushered him into the pub and sat him in front of the fire to warm up. The barman asked the visitor what he was doing on the island? The visitor went on to explain that his fishing boat had capsized in the high seas and somehow he had managed to swim to the shore. The barman explained that he had no communication with the mainland as the radio was not working due to the storm, but the visitor was welcome to stay the night and hopefully the weather would be clearer the next day. The visitor was thankful, and the barman arranged a change of clothes, a meal and then showed him to a spare room where he could rest for the night.

The next morning the weather had changed for the better and the storm had passed. As it was mid-morning and the barman had not heard anything from his visitor, he thought he'd better go up and check on him. The bedroom was empty and the visitor was nowhere to be seen. The clothes that he lent the fisherman were in a pile at the side of the bed and the bed was soaking wet. The barman had no idea how the bed was still so wet – surely the man had dried himself and took off his wet clothes the night before? The barman then went and looked around the island thinking the fisherman must have gone out for a walk and he had missed him as he had left. After exploring the whole island he then checked the dock, but the island's only boat was still tied up, so he could not have left the island. The barman then went to the radio station and contacted the coastguard. He told them the fisherman's name and the name of the man's boat. The coastguard said that they had no record of either the man or the boat but said to leave it with them and they would look into missing persons. That afternoon the coastguard contacted the barman with some information. The fisherman and boat had indeed been reported as missing at sea; however, it was reported missing 100 years to the day.

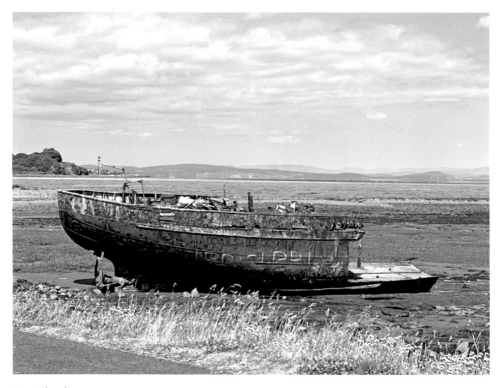

Roa Island.

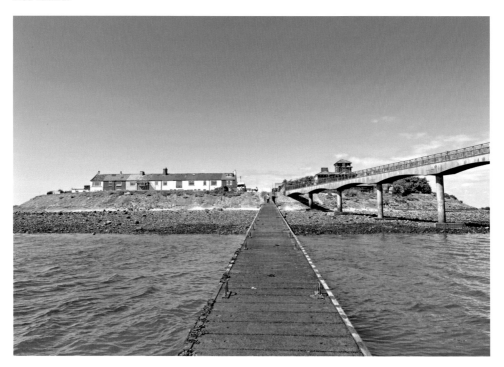

Roa Pier.

Levens Hall, Kendal

Levens Hall is situated near to the River Kent and can be found on the outskirts of Kendal. The hall dates back to the middle of the thirteenth century and was built by the de Redman family. Some of the original architecture can still be seen on the north side of the hall. Originally built between 1250 and 1300, the hall was originally a single standing pele tower, which were quite common across northern England and southern Scotland and were a cross between a fortified house and a small castle. They were built in a way that the inhabitants could withstand attacks from the armies of both countries in an area that was constantly under attack. The pele tower survived its early life and was expanded over the centuries, most notably by the Bellingham family in the early 1600s and again in the nineteenth century. The ownership transfer from the Bellinghams to the Grahme family took place in 1689 in an unorthodox way. It is alleged that the house was put up as a stake in what would have been a very intense card game. The then estate owner, Alan Bellingham, subsequently lost and handed over the keys to the lord of the manor, James Grahme. However, I am not sure how true this story is, as other sources report that Alan liked to live an extravagant lifestyle which led to him having huge piles of debt, which in turn led him to having to sell Levens Hall to James, the main creditor.

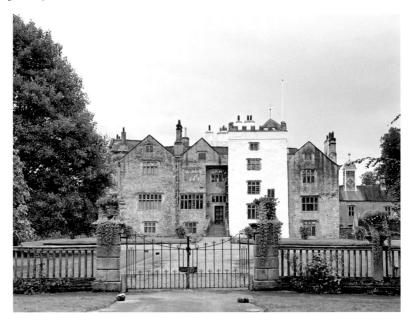

Levens Hall.

The estate would change hands over the coming years and was passed down through the Howard side of the family, who would again extend the building during the early 1800s before being inherited by the Bagots in the late 1800s. The Bagot family still owns the Levens Hall estate to this day and have continued to uphold the building's beauty alongside the outstanding ornate gardens that surround it.

Along with the vast history of the building and the families that have resided within it, Leven Hall also has its own curse. As legend has it, during a stormy night (a great start to a spooky encounter) in the eighteenth century, the hall was visited by an old woman late at night. She was soaked through from the heavy rain and in desperate need of food and shelter. She knocked on the door of the hall only to be turned away. As she walked away she explained that she was a gypsy and would curse the hall and the family within it. The words of the curse are said to be: 'No son will inherit the hall until the River Kent doesn't flow anymore and a white fawn is born in the park.' She was found dead the next morning between the house and the bridge. The reference of a white fawn was made to deer that the estate housed as they were all Norwegian black fallows.

Strangely, no boys were born at Levens Hall, or indeed to the Bagots for over 2,000 years. The first boy to arrive since the curse was Alan Bagot in 1896 and he arrived in the winter when the River Kent was frozen and there is evidence to suggest

The hall's driveway.

a white fawn was born into the herd of deer, something that has been replicated on the birth of every male heir since. But the story doesn't end there, as it is believed the gypsy's ghost still wanders the grounds of Levens Hall. Nicknamed the White Lady, an elderly lady is often seen on the road between the bridge and the house. Unlike most ghost stories, she has been spotted during the day as well as night by the family, staff and the general public visiting the estate. The reports are that an elderly lady appears in the road and people have slammed on their brakes to avoid her, some even jumping out of their car thinking they have hit her. The same figure is also reported to wander inside the house.

This is only one of many sightings of apparitions within Levens Hall, with stories of another lady on a staircase dressed in an elegant flowing dress and looking as if she is en route to a lavish Victorian dinner party. A black dog is spotted running through the hallways and on the same staircase, but whether it is connected to the lady is anyone's guess. Children are also reported in both the hall and the gardens, or their laughter can be heard when there is no one around. Another report is of a large grumpy gentleman who stomps his way out of the house. He is dressed in Georgian-era attire and is said to resemble Alan Bellingham. Maybe it is Alan still furious about losing that alleged card game.

The forest.

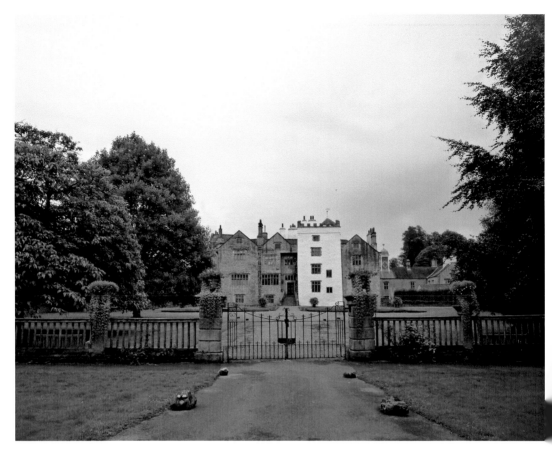

The hall.

Carlisle Castle

Carlisle is only 8 miles from the Scottish border with England and as England's most northerly city it has a long and chequered past. It has been established that the city and the surrounding area was a settlement to local tribes long before the Romans. However, it is with the Romans that Carlisle takes it foothold as a trading post and an important part of England's defences against the Scots.

The Romans arrived in AD 73 and quickly built a fort in Carlisle where the castle now stands. As the Roman population grew from AD 130 onwards the city would go on to be the largest fort along the famous Hadrian's Wall that stretched along the border to Newcastle. The West Road, also known as the Roman Road, still stretches the 60 plus miles between both cities. Carlisle enjoyed a peaceful and prosperous time until the end of Roman rule in Britain.

In 875 all peace and tranquillity was broken in Carlisle with the arrival of the Vikings. The small town that had grew from the old Roman settlement was ransacked and pillaged by the Danes as they took a grip on the British Isles. The monks fled the monastery that had been erected by St Cuthbert in the middle of the seventh century. For the next two centuries Carlisle would be passed from pillar to post, from Dane to Norse, from Viking to Scottish, and from the Scots to the English. The border town would endure these proceedings for many centuries. However, in 1066 with arrival of the Normans, Carlisle started to settle. In 1092, by order of King William II, the castle was built on the site of the old Roman fort and then replaced with a stone structure and more fortifications in 1122. However, this was not to bring peace to the city but to defend it as the Scots were constantly attacking Carlisle. The Scots laid siege a number of times, most notably the three-month siege of 1173 and again in 1644. In 1745 when Bonnie Prince Charlie arrived, his attempts of overthrowing the English ended in many of his Jacobite army being hanged in the streets of Carlisle. Today, the city is a hub of activity with several industries supplying work to its population. The whole area is soaked in history and has many ghost stories including the original Jacobite building that is now Tullie House Museum that has its fair share of apparitions of both Roman soldiers and Vikings appearing in its galleries. Or in the undercroft under Carlisle railway station, where there are many stories of figures being seen and voices being heard. The undercroft was a working hub of passageways and shops during the nineteenth century. Now that is somewhere I would like to spend the night. However, if we are going tell ghost stories of Carlisle, we need to visit the castle.

As I have explained previously, the stone castle that we see today was built in the latter half of the twelfth century and sits on the site of the original Roman fort. Over many centuries, the castle would change hands between the Scots and the English.

It was also pivotal in the fight against the border reivers. In 1567, Mary, Queen of Scots was imprisoned in the castle. As peacetime came in the nineteenth century, the castle still remained mostly intact and with some repairs the castle became the home of many army battalions. Today, the castle still sits proudly above the city and is in the care of English Heritage. It is open to visitors and it is some of those visitors who have reported a number of cases of paranormal activity over the years.

The castle has had its fair share of sightings of soldiers both Roman and more modern day. A soldier has been seen near the entrance dressed in a uniform from the Victorian era, only for visitors to be told there is no one of that description working that day. Romans have been seen mainly at night around the grounds, with one visitor explaining that as dusk settled and the darkness rolled in, he thought he had travelled back in time. However, within the blink of an eye, the Roman soldiers vanished into thin air.

The most famous story is of a young lady that wanders the castle holding a baby and dressed in Scottish attire. She has been spotted for nearly 200 years and it is believed she is the spirit of a young lady bricked up in the castle walls. Her skeleton was found in the 1830s and she has appeared ever since. Another quite bizarre story is of a group of ghostly figures that are spotted hiding behind walls and in the shrubbery. They are then spotted running towards a wall and disappearing through it. Not long

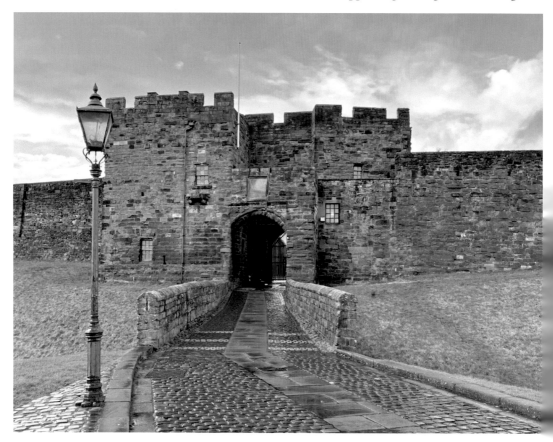

Carlisle Castle.

after these men are spotted, a man by himself is reported to be seen running after them whooping with joy before disappearing into the wall as well. Could this be the ghost of 'Kinmont Willie'? Kinmont Willie was a local border reiver imprisoned within the castle. When his gang broke him out of jail, they all escaped over the wall. Maybe visitors have spotted this replay of history dating back to 1596.

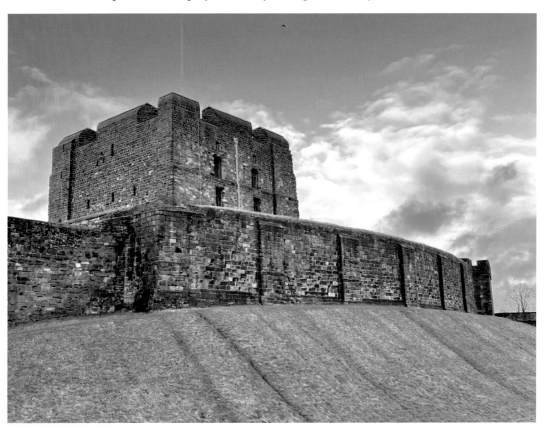

Castle wall.

Wray Castle, Claife

Nestled in the beautiful countryside north of Lake Windermere sits Wray Castle. Although named a castle, Wray is actually a country manor house built in 1840 by James and Margaret Dawson. James had been a surgeon from Liverpool, while his wife had received a sizeable inheritance from her father's estate. He had made his fortune through gin and brandy before branching out into other industries. The Dawsons had become well known in Ambleside over the years as they had visited many times, enjoying the tranquillity of the Lake District to escape their more hectic lives in Liverpool. It was almost inevitable they would retire to the area and in 1840 they bought land in Wray and built the castle with Margaret's inheritance. Over the years the couple developed the surrounding area, the most notable addition being the church of St Margaret in Low Wray. The Dawsons would enjoy the castle and life in the area for over twenty years until Margaret passed away in the castle in 1862, with John also dying in the castle three years later in 1865. As the couple had no children the estate was inherited by Margaret's fifteen-year-old nephew, Edward Rawnsley. The teenager did not move into the castle but hired it out as a holiday home (a Victorian Airbnb). During this time, Wray Castle held the prestigious claim that it was the inspiration for the Beatrix Potter novels, as she holidayed at the castle for her sixteenth birthday and fell in love with the Lake District. Over the following decades the estate was sold several times, until it was purchased by the National Trust in 1929. Since its purchase by the National Trust, Wray Castle has been used as a youth hostel, a conference centre, offices and as a training school for the Merchant Navy. Today, the castle is open to the public as a tourist attraction.

While researching Wray Castle there were few ghost stories concerning the building, although there were a couple of reports of the surrounding estate being haunted by a man on a horse. No one knows who the horseman is or even could be. The forest has stories of imps, fairies and daemons that run around the shrubbery. However, when I visited the area, a couple of locals had a different view and shared some stories that they had heard over the years. A man is often seen wandering around the castle, walking along the walls and up and down the stairs. He has been seen looking out of the upstairs windows, gazing over the gardens and taking in the views. He is described as being dressed very smartly in a tweed suit and he looks like he is from the Victorian era. He never speaks to anyone and disappears into the house as quick as he appears. It's reported that there is a distinctive smell of alcohol when he is spotted. The smell of alcohol leads us to two possibilities. Could this be John Lackson Lightfoot? John was the original architect of Wray Castle, but unfortunately John died before the castle

was completed and it is reported that he drank himself to death, hence the smell of alcohol. Is he revisiting the castle to see his completed work? Or could it be James Dawson himself returning to the home he loved so much and the smell of alcohol is the lingering smell of a Victorian surgeon living in an era when alcohol was heavily used? As always, I will let you decide.

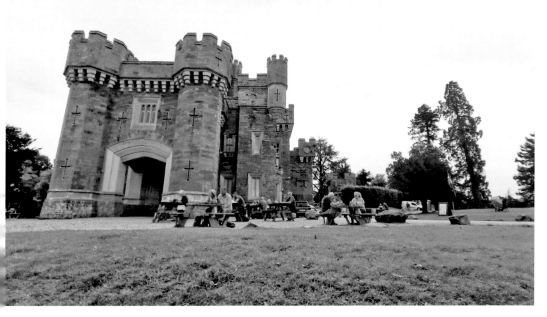

Wray Castle and grounds.

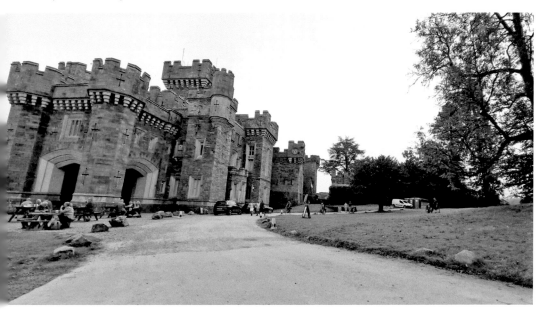

The grounds are said to the home of fairies and daemons.

The imposing surrounding wall.

The Grange Hotel, Grange-over-Sands

As you walk around Grange-over-Sands you could pick almost any of the buildings and imagine them featuring in a ghost story. This quaint seaside town is full of Victorian buildings that popped up as the railway arrived in the late nineteenth century. Mentioned as early as the fifteenth century as an outpost of the nearby Cartmel Priory, the town was called Grange-with-Kentisbank. The name Grange suggests that the priory used the area to store grain and could have possibly been

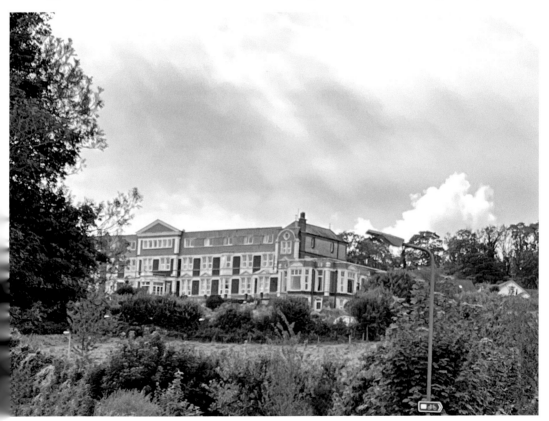

The old Grand Hotel is now an old people's home.

used as a small port to transport the grain down through Morecambe Bay as roads would be few and far between. It is not mentioned again until the 1700s when reports suggest that it was a growing fishing village with at least one inn. Its visitors were restricted to a few boat trips as access to the village was not the easiest, and it is believed that there were many deaths out on the sands as people tried to cross by foot or horse only to fall foul of the rip tides and quicksand. These poor souls may explain the ghostly sightings of horses walking across the bay at low tide. The railway arrived in Grange-over-Sands in 1857 and changed the fortunes of the locals overnight. The small fishing village became a seaside holiday town visited by thousands every year as its reputation grew, and it became known as the 'Torquay of the North'. Building work started and progressed quickly to keep up with demand. Several hotels and numerous pubs were constructed with the introduction of the promenade on the seafront in 1904, which is still a pedestrian-only area today. The peaceful and tranquil ornamental gardens were opened in 1865 and are still in full bloom for all to enjoy. After the Second World War, the road network improved and as people started to take more summer holidays at holiday and caravan parks, Grange-over-Sands enjoyed its fair share of holidaymakers thanks to its location being ideally situated to visit Windermere, Kendal and Morecambe.

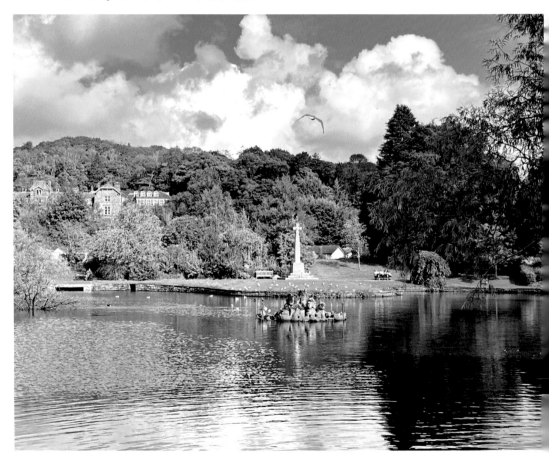

The ornamental gardens.

Grange-over-Sands has encountered a lot of paranormal activity. The sounds of singing and dancing in the Victoria Hall on Main Street when the hall is empty has been reported several times, which would make sense given how the hall was used during the early 1900s. Victorian children have been seen running around the ornamental gardens both during the day and night, although there are no reports of any tragedies in that area. But the building I found the most fascinating was the hotel on the hill that overlooks the town and bay. Its distinct design did make me think of Norman Bates' house in the film *Psycho*. However, the part of the building that is attached is a fine example of Victorian architecture. After a short walk I discovered the building was The Grange Hotel.

The Grange Hotel was opened in 1866. It was built to be a station hotel by the railway companies and served the public for over 150 years and seems to have several residents that have forgotten to check out. One of the rooms is reported to have a presence that is not very friendly. The room has been known to be freezing even through the summer months or when the heating is on full power. Guests have reported the room temperature dropping unnaturally to the point of thinking a window has blown open. The same room is not a favourite for the maids when it comes to cleaning, with reports of being pushed or the doors in the room slamming shut with no rational explanation. The room leaves them feeling uneasy as if someone is watching them. However, these reports were from a couple of decades ago and no one seems to have any recent accounts of any activity. Maybe the resident has now left.

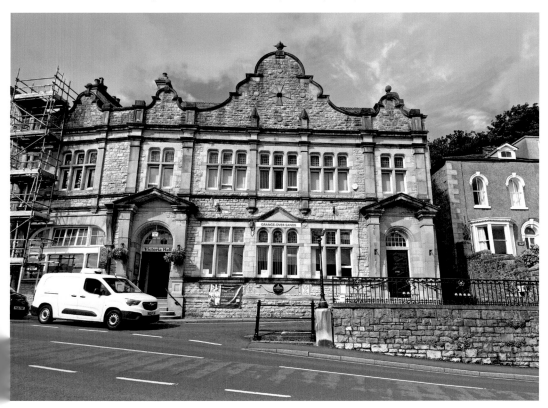

The Victoria Hall.

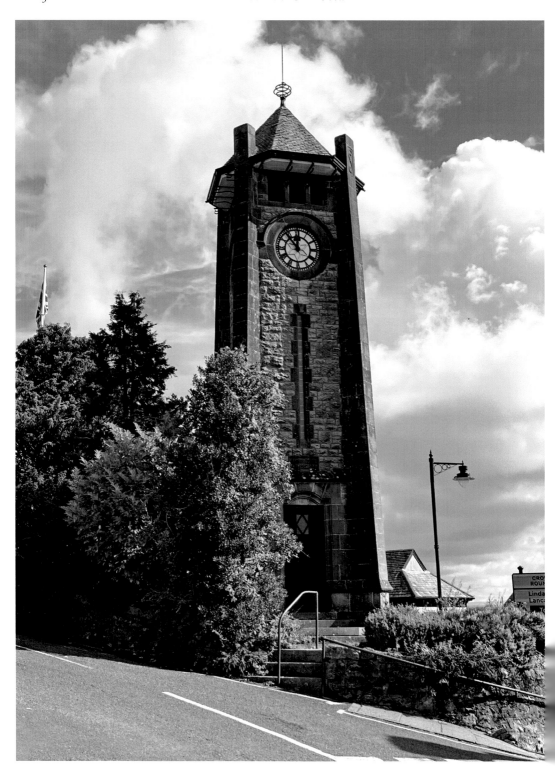

The clock tower.

Views across the bay.

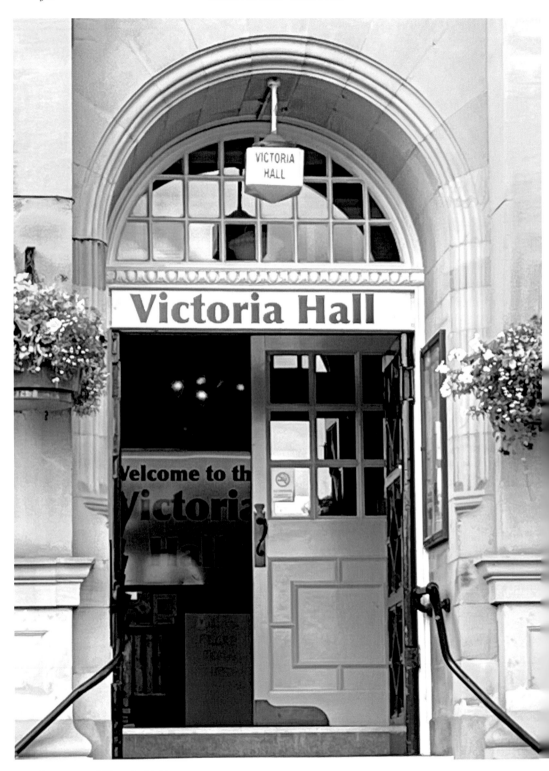

Entrance of Victoria Hall.

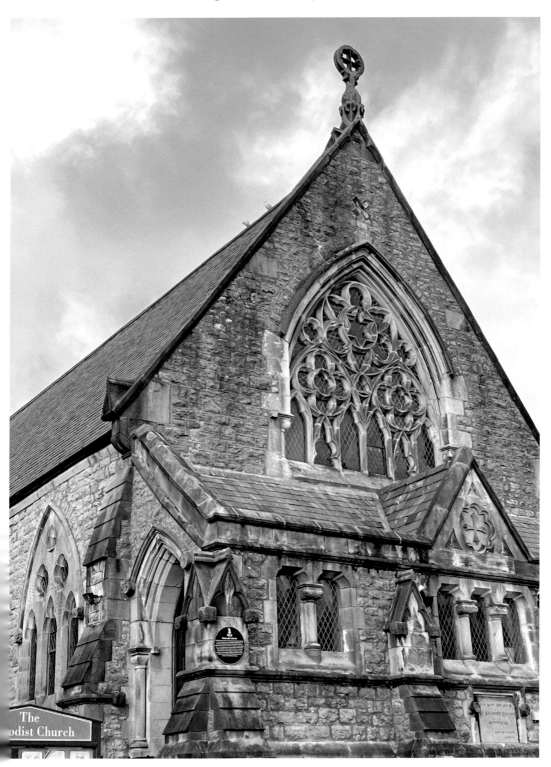

The old Methodist church.

The Inns of Ambleside

Ambleside is a small town on the northern shores of Lake Windermere. It stretches from the shores of the lake up the hill and the town centre sits overlooking the lake with some outstanding views. The Romans settled in this area and built a small fort on the shores called Galava. It is believed that it was built in AD 79 and was used to protect the area around the lake and the roads that ran to the nearby forts at Kendal, Kirkstone and the further afield major settlement at Carlisle. The Romans stayed for 300 years before their empire crumbled and they moved back to Rome. There is not a lot of history known for the next 1,000 years with little evidence of who took over the fort, although as with most of England it would have been local tribes and the Saxons. There is some evidence that the Vikings settled in the area, with the town's name believed to be the Norse word for summer pasture or sandbank. We know that a number of mills stood on the banks of Stock Beck as far back as 1454 as the rebuilt mill on the site is now The Flying Fleece. Just down the road from the old mill is Bridge House. An oddity of a house built over the beck and often referred to as the most photographed building in Cumbria, the tiny house dates back to the sixteenth century. In 1650, James II granted Ambleside a market charter and the town started to grow. Numerous coaching inns, shops and houses started to appear around the market square, most of which were built with the stone from Galava or slate that had come from the local quarries. Over the next two centuries, Ambleside became known for its woollen mills and in the nineteenth century saw the arrival of the tourist. At first the locals tried to resist the town becoming a centre for tourists from the industrial cities of Lancashire and Yorkshire, but after the war with more visitors coming by car and the disappearing wool trade, Ambleside had to change. Its economy is now mostly built on the tourist trade.

There are a number of buildings of note in the town and all of them have a ghost story attached. The ruins of the Galava fort down on the lake have had the obvious sightings of Roman soldiers around it. There have been reports of Roman boats seen on the lake heading towards the fort, which I must admit is a first for me. However, the most interesting sighting is of a legion that was spotted marching up the hill heading towards Kirkstone. In the town centre is Bridge House, which I have already written about, where there have been reports of children looking out of the windows at passers-by. I do feel a little apprehensive of these reports as it is one the most photographed buildings – surely we would have some very strange pictures by now. The clock tower attached to the market hall has a couple of reports of paranormal activity that are quite recent. Both reports are a few years apart but in both of the reports the witnesses say they saw someone looking out from the windows at the top

of the tower when the tower was closed, and they have no explanation of who it could be. The clock tower is in the centre of the town along with several pubs and each pub has a story attached. The first covers the two oldest pubs, The Priest Hole and The Royal Oak. I have put them together as I was told the same story about both buildings. It is said a young man walks through the pub dressed in a dirty shirt and shorts. His clothes looked to be from the eighteenth century. He takes no notice of anybody and vanishes into the wall at the back of the pub. He is often seen early in the morning or later at night. However, the pub that I was told the most distinctive story about was The White Lion Hotel. The hotel has stood in the centre of Ambleside since the 1700s and was a coaching inn back in the days when the main form of transport was horseback and stagecoaches. I cannot find anything in the history books to support this story but I'm going to tell it as I was told it. So, a businessman was travelling from the Southern Penisula back to Carlisle after visiting the area on business when the weather began to change. The driver of his stagecoach suggested they stop for the night and continue their journey the following day. As the snow was falling quite heavy and the wind was getting stronger, he agreed, and the stagecoach arrived in Ambleside. After trying a couple of the inns, the only room available was at The White Lion. The businessman decided to have a couple of drinks in the bar near to the fire before retiring for the night. A young lady approached him and asked if she could join him for a drink, to which he agreed. One drink turned to many and before long both of them were laughing and joking. It was starting to get late, so the lady asked if the businessman would walk her home. Seeing the weather outside he agreed. What he hadn't noticed was that the lady had been accompanied by two men and earlier the three of them were taking a great interest in the large bag of coins the businessman had in his coat pocket. The businessman left the inn with the lady and as they passed the horses and coaches tied up at the back, the two men appeared and with a quick whack over the head the businessman fell to the floor bleeding from the wound. The lady quickly bent down and stole the bag of coins from him, and the three thieves ran off into the night. The businessman was left on the floor and quickly passed out. Unfortunately, he wasn't found until the next morning, frozen to death from the weather. The murderers were never found. Whether the local constabulary were informed and never solved the crime or whether the man was believed to have slipped in the snow and banged his head after one too many brandys we'll never know. But, on snowy nights there has been sightings of a man crawling around in the car park outside The White Lion, but by the time someone runs outside to help him he is gone. He is also reported to have been seen in the bar area and the upstairs corridor, still dressed in his expensive suit, blood coming from his head and muttering, 'They stole my money'.

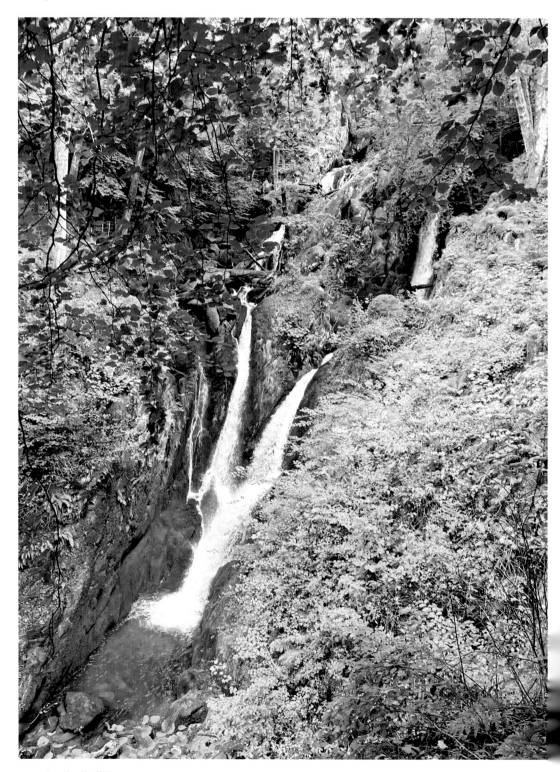

Stock Ghyll Force.

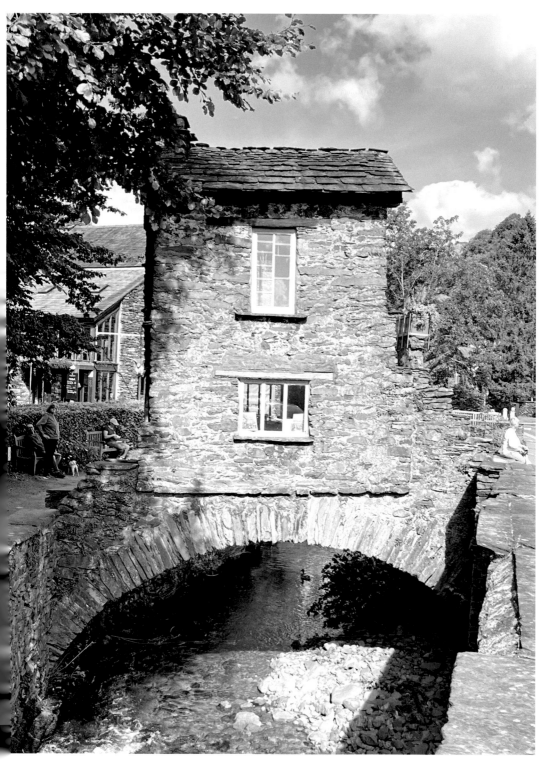

Bridge House.

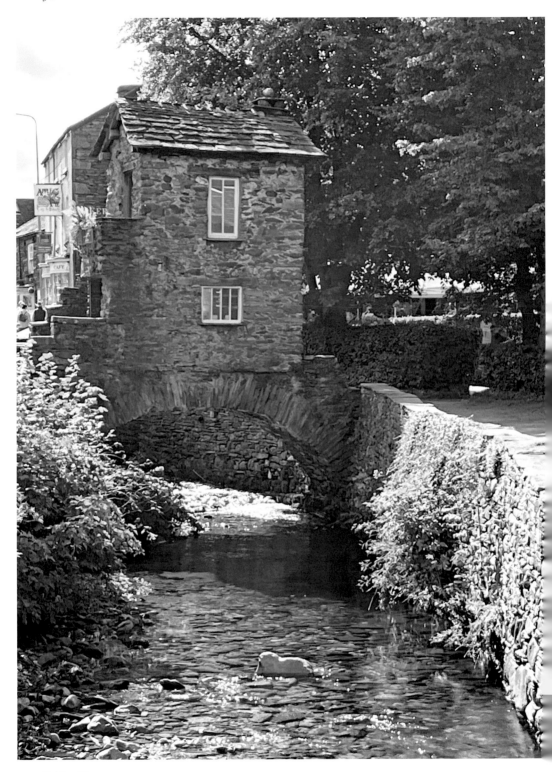

Bridge House.

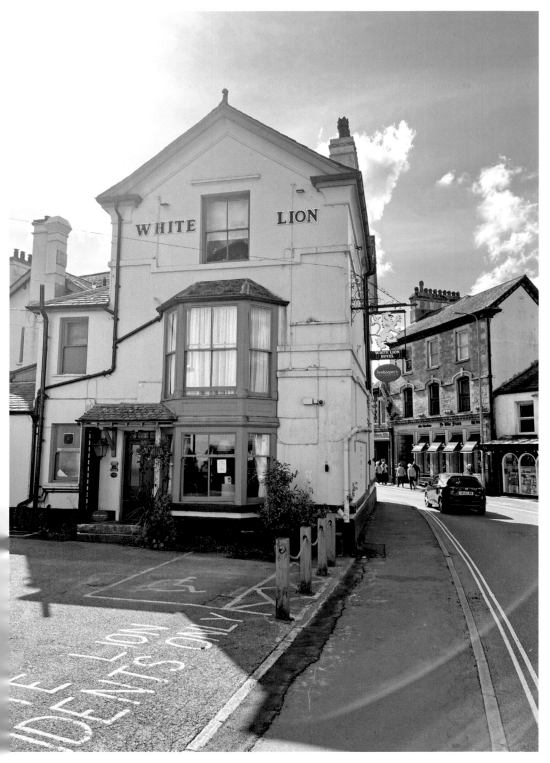

The rear of The White Lion.

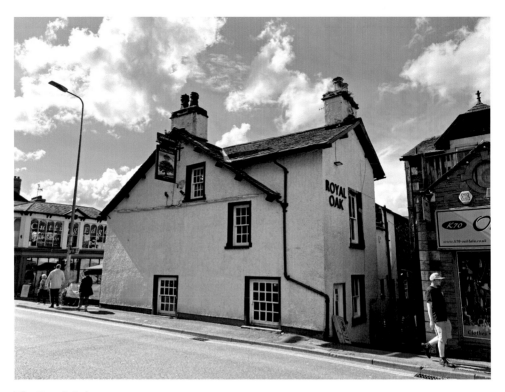

The Royal Oak.

The White Lion.

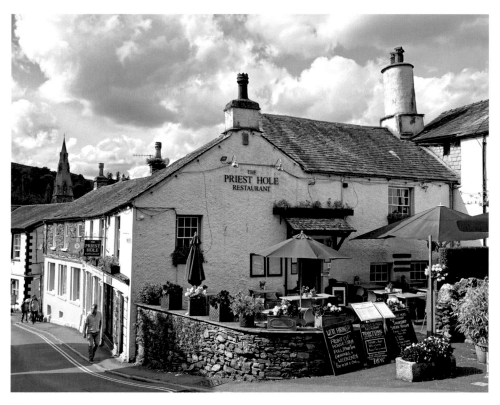

The Priest Hole.

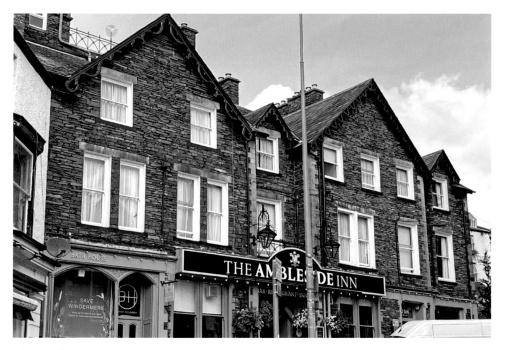

The Ambleside Inn.

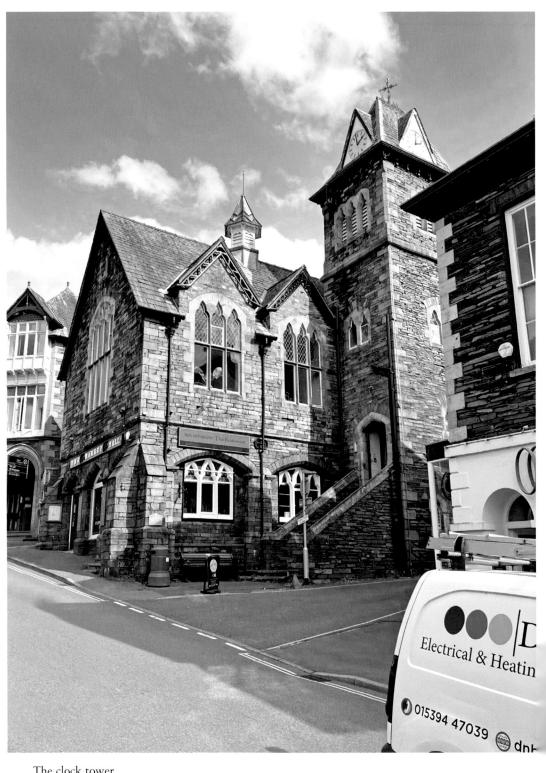

The clock tower.

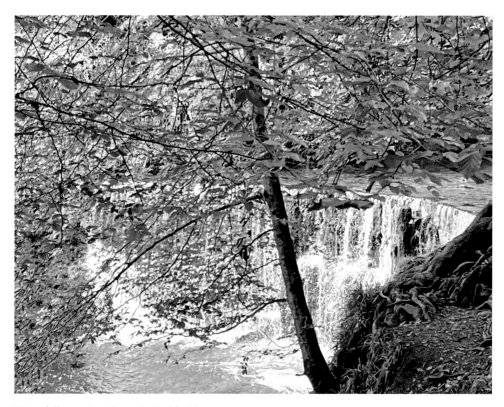

Waterfall running through Ambleside.

Ambleside village.

Kirkland Old Town, Kendal

Kendal is a large town in the southern part of the Lake District and is probably known around the world for its famous mint cake. However, as you delve into the town's history, it has quite a tale to tell. The Romans built a fort on the outskirts of the town called Watercrook in AD 90, which was part of the larger network throughout Cumbria and stayed for the following three centuries. Local tribes took over the fort and enjoyed life in the area. Kendal then reappears in the Domesday Book in 1085 when the Normans had moved north and built Kendal's first castle, Castle Howe. The castle would defend the town until it was abandoned in the twelfth century when it was replaced by the stronger, more fortified Kendal Castle. Kendal Castle was built at the start of thirteenth century and its ruins can be seen today. Its claim to fame is its inhabitants, including the Parr family, whose daughter Catherine would be the last wife of King Henry VIII and remembered as the one that survived in the well-known rhyme. Richard I granted the town its first royal charter in 1189, allowing it to have a market, and Kendal started to expand. Wool would become the town's main industry and export. It would be a major part of its economy for the next 600 years. Today Kendal is a hive of activity attracting tourists from around the globe. When looking for ghosts in Kendal you could head out to the castle where the figures of Scotsmen are seen marauding around its walls or a lady stares across towards the town. You could visit the Town Hall where there have been reports of doors opening and shutting by themselves and footsteps heard through its corridors when no human is present. Ye Olde Fleece on Highgate is worth a visit. Originally known as The Golden Fleece, the pub dates back to 1654 when it is believed to have been a butchers and the inn was next door. With nearly 400 years of history, it is not surprising to hear reports of paranormal activity including cold spots and temperatures dropping for no reason, voices being heard coming from the bar when it is closed and footsteps being heard upstairs and on the staircases. Unfortunately, I have never heard of anybody seeing any form of apparitions, although cutlery and crockery has been seen to move of its own accord. Another site on Highgate is the old Santes Hospital, once a school, library and almshouse. The hospital's gatehouse still stands proud on today's main street. Reports of young Victorian children running around and Georgian woman are reported under the archway, looking out as if they are waiting for someone to arrive.

However, the area that I have heard the most ghost stories about is Kirkland Old Town. The old town is situated at the southern end of Kendal's town centre and surprisingly was an independent village until 1908 when it came under the umbrella of the Borough of Kendal. When you first arrive in Kirkland the first thing you notice

is a fantastic parish church that dates back to the thirteenth century. The church we see is built on the land of former churches dating back to the Anglo-Saxons. It is surrounded by an array of eighteenth-century houses and buildings all with their own stories to tell. Today you can see that they were built with very thick walls and had heavy gates across their entrances. It is believed this was a way to keep the Scots out as they raided Kirkland many times. The ghost stories in this interesting old town are many and very varied. The parish church, although beautiful both inside and out, has had reports of the screams of woman coming from inside, but when those screams are investigated there is no one there. It is believed that it could be the poor souls of 1210 when Scottish raiders attacked Kendal and murdered all the women and children that had taken refuge in the church. Next to the church is Abbot Hall. The hall was built on the land of the original Abbot's Hall that was destroyed after the Dissolution of the Monasteries. The hall was built in 1759 by Colonel George Wilson, whose father was a local landowner and member of the gentry. During the twentieth century, the hall was restored from a ruinous state to an art gallery. Feelings of being watched as you walk around the gallery have been reported. In the outside yard, eyewitnesses have reported seeing monk-like figures moving around. It is believed that the long-gone colonel is still seen at the riverside next to the hall. He was renowned for taking a daily walk along the river to the extent that the path is now known as Colonel's Walk.

As we continue around Kirkland, we come across the Ring O' Bells public house. The pub was built in 1741 by the reverend of the church and claims to be the only pub built on consecrated land. It became a regular for the reverends and wardens alike. The links to the church do not stop there as it is rumoured that the dead were laid out in the backroom before funeral services at the church. Ring O' Bells is alleged to be one of the most haunted pubs in the country, with the number of spirits residing there purportedly in double figures. The feeling of unease in the cellar and activity across the building has been reported for past two decades. Recently, a video capturing a glass being pushed off a table has caught the attention of the national press and can still be viewed on YouTube.

The final story from both Kirkland and Kendal is probably the most eerie and bizarre at the same time. I have been told the story of whispering walls many times over the years. Visitors to the town have told me they were walking down some of the alleys and lanes in Kirkland Old Town when they were stopped in their tracks as they heard someone talking to them. It's usually described as a loud whispering but when they look around there is nobody there. As they continue walking, the whispering starts again. The people I have spoken to have said that when they stop and concentrate on where the voices are coming from, it sounds like the walls are talking. Believe me when I say that I had a couple of the visitors say at the start of the story, 'Please don't think I'm mad but…' They looked surprised when I point out on a map where they were when they encountered these whispering walls. Could it be the voices of an anchorite sect that lived between the parish church and the Anchorite Well. The anchorites used to live in cells made out of stone. The walls would have a slit in them for the members of the order to talk to the outside world, with most of their communication being quiet prayer. Could these modern-day reports give 'if the walls could talk' a new meaning?

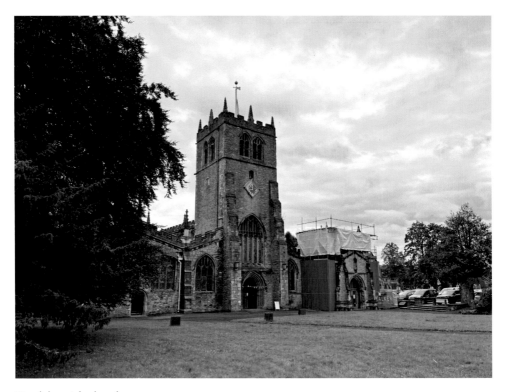

Kendal parish church.

Inside the church.

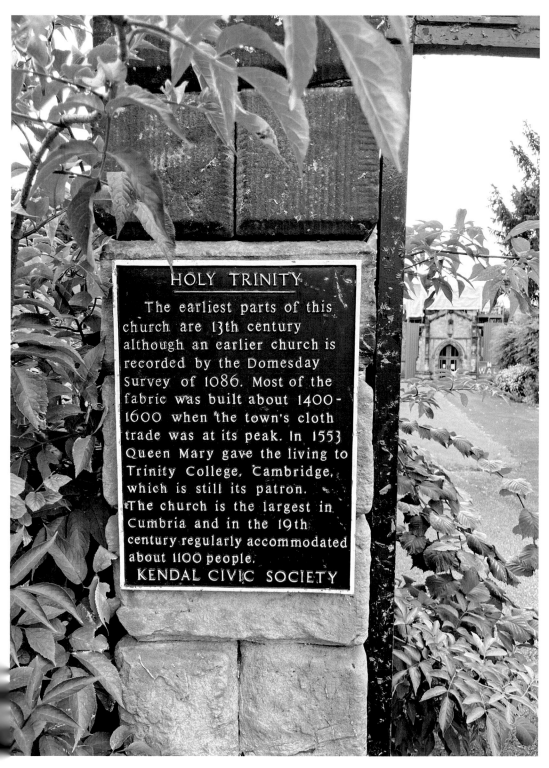

HOLY TRINITY

The earliest parts of this church are 13th century although an earlier church is recorded by the Domesday Survey of 1086. Most of the fabric was built about 1400-1600 when the town's cloth trade was at its peak. In 1553 Queen Mary gave the living to Trinity College, Cambridge, which is still its patron. The church is the largest in Cumbria and in the 19th century regularly accommodated about 1100 people.

KENDAL CIVIC SOCIETY

Name plate.

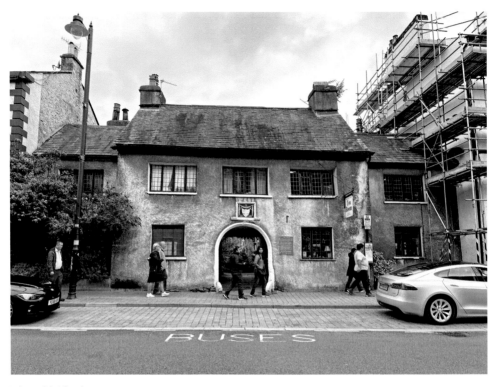

The Old Almshouse.

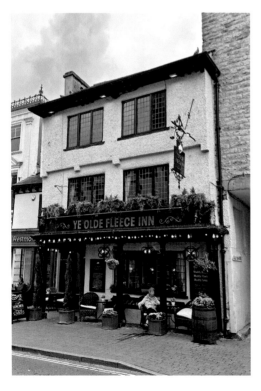

Ye Olde Fleece Inn.

River Kent.

The old graveyard.

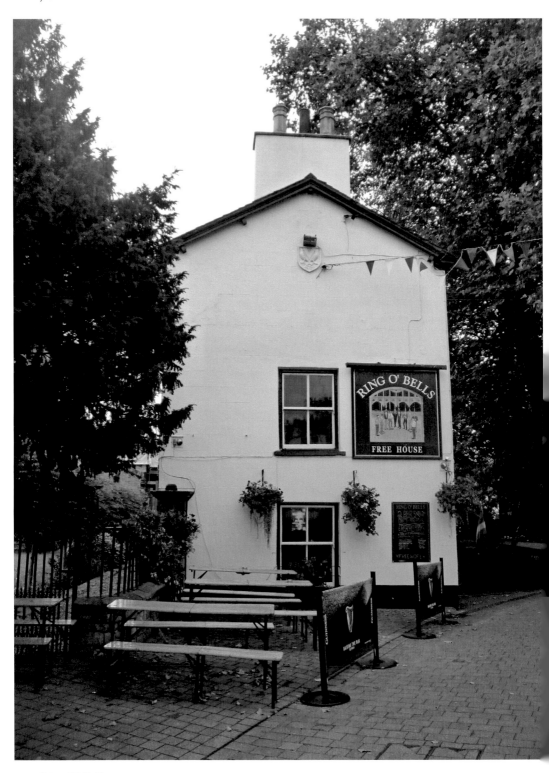

Ring O' Bells.

The Town Hall.

Abbot Hall.

The Ghost House of Grasmere

Grasmere village is a small hamlet in the centre of the Lake District that sits a third of a mile from the shores of the lake with the same name. The village dates back to medieval times as the church is named St Oswald's in tribute to the King of Northumbria that ruled during the seventh century. The name Grasmere suggests more Viking links as it is believed to derive from the Norse words meaning grass and lake. The church we see today was built during the 1300s and sits on top of the original church, a place that is reported to be where Oswald himself would stand and preach.

Modern-day Grasmere doesn't appear until the nineteenth century and the arrival of tourism. This can be seen by the number of large Victorian buildings that were once used as guest houses and hotels. Grasmere's tourist industry was boosted at the time as it became famous through the words of William Wordsworth, who described Grasmere as 'the loveliest spot that man hath ever found'. Wordsworth would spend most of his life in the village, finding his surroundings the ideal inspiration for his poems. William was buried in St Oswald's Church after his death on 23 April 1850.

Grasmere today is still a thriving tourist centre with visitors from across the world coming to see Dove Cottage (home of Wordsworth), St Oswald's Church and its graveyard. The village is used as an ideal starting point for walkers who want to climb Helm Crag as the mountain peak overshadows the village.

I am not aware of many ghost stories or reports of paranormal activity in town, but I was told a story by one of the team leaders at GHOSTnortheast that involved a house in the village. Peter Woolford (team leader) reminisced about when he would visit the Lake District with his parents in the 1970s. As a family they would stay in a rental property in Grasmere and some extremely strange events unfolded.

The following is the story he told me. However, I have changed the details of the building as I do not want any current owner to feel uncomfortable with what could be their dream home. But what I would say is if you do recognise the activity and think you know where we are talking about, please send me an email and let me know.

We are starting back in the very early seventies, probably 1973, when Peter first visited Grasmere with a group of family and friends for a summer holiday. This would be the first of many over the next few years. Peter was a nine-year-old boy and was excited to be on holiday, spending time with his family – not forgetting his dog. He describes arriving at the bottom of a long driveway surrounded by trees and the large Victorian house was on the fells overlooking the village below. He can remember that you could see the village through the trees when you looked out of the second-floor

windows. He said he could remember the inside of the house in great detail as if he had only been there yesterday. He went on to explain:

You would walk through a large front door and on the ground floor was a bedroom on one side and the hall leading to the back of the house where the living room and kitchen were. There was a big staircase that took you up to the first-floor bedrooms and a bathroom that still had a Victorian bath that stood on claw feet. The staircase turned back on itself as you went up with a landing halfway up that was roughly 15 to 20 feet long. On the landing was big stained-glass window. Although the window took in the sunlight during the day, the landing area always seemed a bit dull as the light was split into the various colours of the stained glass. To be honest, I cannot recall if the window was a picture or just a pattern. What I can also remember vividly are the banisters up the stairs and along the landing, where there were tall spindles. The spindles would have been as high as my neck, and I was not a short nine-year-old boy. I loved the place; the whole family loved the place. I would wander around the house with my dog at ease until I came to the landing. For some strange reason I would run along the landing every time, including the years that followed. There was just something about that space that I couldn't deal with. It was always cold, which I could never explain as you could feel the heat on the window from the summer sunshine. My dog would never stay on the landing. He loved nothing better than to stretch out on a good strip of floor, and the landing seemed perfect. He could have stretched out under the window but he, like me, seemed to want to cross that landing as fast as he could. However, even scarier than the landing was looking over the banister downstairs. It terrified me. It was not a safety issue as the spindles were high. I just felt so uneasy and can remember how my heart started to race if I dared to even take a quick peep.

Over the years of visiting and as I got older the feeling in that area never changed. It was not until my teens that I would hear a chilling story that would maybe provide an explanation.

Every morning on holiday I would walk with my dad to the village store. We would be warmly greeted by the storekeeper and my dad would buy the newspapers and I would collect the freshly baked Grasmere gingerbread from the church shop, a delicacy I still visit The Lakes for today.

The morning was no different to any other and the three of us were chatting around the counter when the storekeeper started to joke about not going out at night or the king's men will get you. Obviously being an inquisitive teenager I asked him what he meant. He then went on to tell me the story of the ghosts of the king's men at Dunmail Raise. King Dunmail was the legendary last King of Cumberland and was defeated by King Edmund on the fell near the entrance to Grasmere. His soldiers were ordered to bury Dunmail's body under a pile of rocks so that he could never return from the grave to challenge King Edmund again. Edmund then slaughtered Dunmail's soldiers, with a lucky few escaping up into the hills. The pile of rocks created a cairn that is still there today and the passage through to Grasmere is called Dunmail Raise. Local folklore says that King Dunmail's men still roam the landscape watching over the king's body, hence the saying the king's men will get you. My dad was laughing and asked if I was spooked and I told him and the storekeeper, not as much as the landing of the house spooks me. It was the storekeeper's turn to ask me

Wordsworth's gravestone.

what I meant. I explained the feelings I had in the house, and he rather casually said that it didn't surprise him. Confirming the house name of where we were staying, he then told us how a previous owner had hanged himself from the landing years ago. I felt a cold chill run through my body and asked him if he knew anything else about it. He said he knew very little but one day the owner tied a rope around the spindles on the landing and threw himself off. He was later found dead by the housekeeper, and no one knew why he had done such a thing. It all made sense if you believe in ghost stories. Strangely it wasn't until years later when reminiscing about the old holidays with my nanna that she told me how uncomfortable she felt on the landing, never the stairs but specifically the landing, and she had been unaware of the story until I told her years later. I remember in my later teens I was reading a book by Stephen King called *Salem's Lot*, and the main character says, 'the truth of what a nine-year-old boy sees and what the man remembers twenty-four years later', took me straight back to the Grasmere house.

I asked Peter if he saw or heard anything over the years he visited the house, but he said that he had not seen anything. He had heard creaking on the stairs like someone was coming down them but explains that it could have easily been the noises of an old house and a young, overactive imagination. What he constantly repeated was the feeling of dread when near the spindles and how cold it was in that area. Was Peter's feeling connected to the house's sad story of a suicide? As always, I will let you decide.

View over Grasmere.

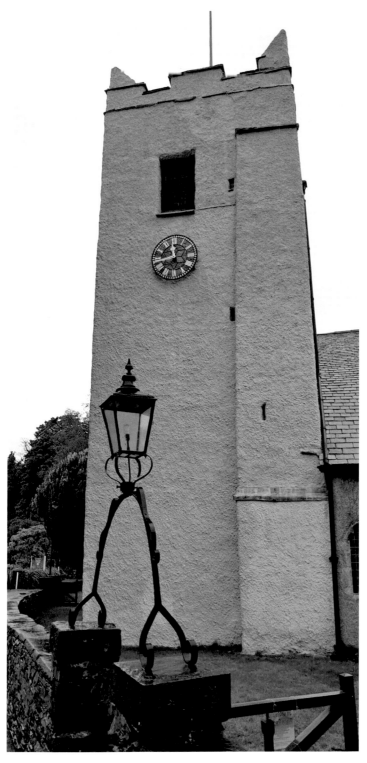

Grasmere parish church.

Views to Grasmere.

On the lake.

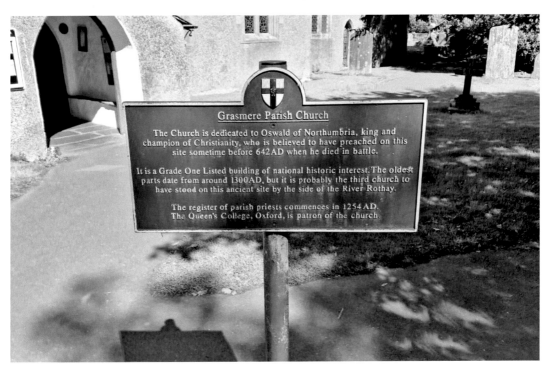

The parish church.

Boats of the lake.

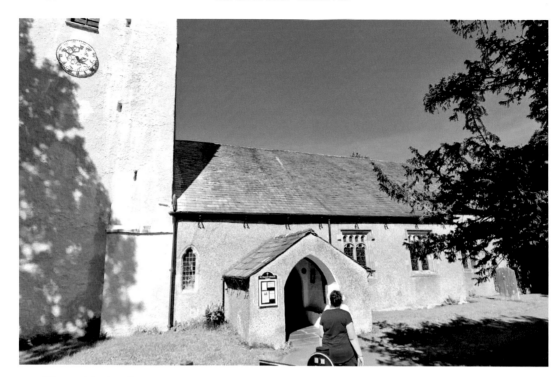

The parish church.

Helm Crag or The Lion and the Lamb.

Long Meg and Her Daughters, Penrith

If you have read any of my previous books, you will know I love a good story about witches and their covens. I find the whole witch trials era fascinating along with its colourful stories of women turning into cats or rabbits and tales of Witchfinder Generals being paid huge amounts of money to convict elderly ladies using nothing more than trickery. Thousands of lives were lost over a short period of time based on hysteria and false accusations. Cumbria is no different to the rest of the UK with its eccentric stories of its resident witches.

Up on a hill above Penrith you will find the small village of Little Salkeld. This quaint little village, which dates back to 1292 and comes complete with a manor house called Salkeld Hall, is no different to many villages that lie in the English countryside. Probably the most unusual fact is that it has a vicarage but no church. So why am I taking about it? Little Salkeld is the nearest village to Long Meg and Her Daughters. It also has the bonus of being on the route to Lacy's Caves. Both Long Meg and the caves have supernatural tales and reports of paranormal activity. But most importantly for this chapter, they have stories of witches.

Long Meg and Her Daughters is a stone circle that dates back to Neolithic times and, believe it or not, stone circles are not that uncommon throughout the British Isles, the most famous obviously being Stonehenge. Originally the circle was made of fifty-nine stones; however today, there are only twenty-seven stones still present including Long Meg, a 12-foot-high monolith surrounded by her daughters. Only a few hundred yards away is another circle, known as Little Meg. The reason for these circles is still unknown with many theories ranging from religion to sundial clocks and calenders. I have even been told they are ancient landing circles for alien spacecraft. However, I love the story of Long Meg being the remains of a local witch who was turned to stone by a Scottish wizard.

Meg from Meldon was a well-known witch throughout Northumberland and was known to visit covens across the county border. She would meet her coven on the outskirts of Brampton before climbing the hills above Penrith so they could practice their craft. It is said that Meg and her coven were dancing on the Sabbath and citing rituals on the hilltop when they offended a wizard who had joined them. The wizard is said to be Michael Scot, a Scottish mathematician who took to dark arts in his later life. As Michael became angry with Meg and her coven, he decided to use a powerful spell that turned them into the stones we see now and cast a spell upon the stones.

The spell cursed the stones and those entombed within them, and the only way to break the curse is by counting the stones twice with the same result. Others say that if you count the stones correctly and put your ear to Long Meg, you will hear the whispers of Meg the witch.

While this story is hugely entertaining, I have no idea where it originated. Michael Scot, the wizard, died in 1290 and Meg of Meldon died in 1652, and would a witch who lived in Morpeth, Northumberland, have travelled nearly 80 miles to meet up with a coven? However, Michael Scot was never formally identified, and he was presumed dead. But could he have returned from the grave with rumours that he was in league with the devil himself? The information regarding Meg is similar; I suppose she could have travelled the distance on her broomstick or if she had turned into a fast creature as folklore claims. She is listed as being buried at Newminister Abbey near her hometown of Morpeth, but there were many reports that she was spotted after her funeral in Meldon, leaving locals wondering if she was a ghost or had done a deal with the devil.

We will probably never know who built Long Meg and Her Daughters or the reasons why, and we'll probably never understand the meaning of the various markings, but the area is awash with paranormal reports. There are reports of witches spotted dancing around the stones in the moonlight. Some of the accounts of witches say a group are gathered around a cauldron in the centre. Druids or pagans have been sighted, along with sounds of chanting. All the reports involve groups of people who simply vanish as you get closer to the stones.

A few miles from Long Meg you can find Lacy's Caves. It is an unusual structure of five hand-carved caves in the side of the small cliffs that loom over the River Eden. The caves were built by the landowner, Samuel Lacy, who resided at Salkeld Hall in the late eighteenth century, but we don't know why. One theory is that he built them as changing rooms and cover for when he had guests on the estate who wanted to go swimming in the river. The caves are beside the deeper areas of the river. However, the story I was told, and I enjoyed the most, revolved around Long Meg and Her Daughters. It is said that Samuel Lacy had ordered his farmers to remove the stone circle up on the hill so he could use the fields for crops. His workman arrived in the evening to survey the field and decided to start the removal of the stones the next day. That night there was a huge storm and the field became waterlogged, so the workmen couldn't access it. Samuel then turned up and cancelled the work immediately. He claimed that Meg and her coven of witches had visited him in his dreams and warned him against removing the stones. As a punishment he was to build them somewhere sheltered nearby where their spirits could gather to practice their magic. He then ordered a local craftsman to build the five caves we see today. In the dead of night, a group of women have been reported in the caves gathering around a fire. Other reports are of a man seen sitting in the entrance of the caves looking out over the river below. When he is approached, he smiles without speaking and gets up and walks into the caves. When the person who has spotted him follows him into the caves, he is nowhere to be found, leaving the ramblers very confused. He is described as wearing a strange black triangle hat, a three-quarter-length dark jacket and tight trousers or tights. This would be a typical description of a member of the gentry in the Stuart period. Could this be the spirit of Samuel Lacy enjoying his estate?

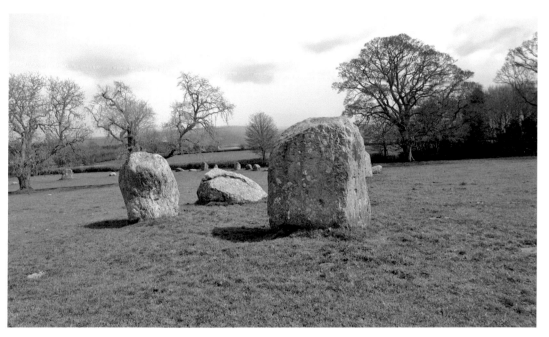

Are they the witches' coven?

The stones at dusk.

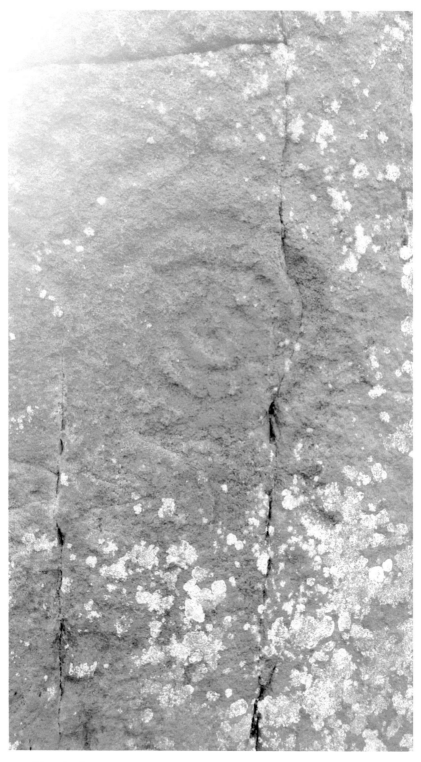

Ancient markings in the stones.

Humphrey Head and the Last Wolf

Humphrey Head is an outcrop of land that sticks out into Morecambe Bay between Grange-over-Sands and Ulverston. On top of the peninsula is an important area for wildlife. Covered with plants and a small wood, it is the home of peregrine falcons, to name one of many birds. Around the base of Humphrey Head where it meets the sea is even more interesting as it is home to a holy well. In times gone by it is said there was a small house or hermitage next to the well and it would be visited by people from miles around to bathe in and drink the water that was meant to have healing qualities. The well is still there today, trickling out of a pipe from the side of the cliff, but unfortunately there is no evidence of the hermitage. But Humphrey Head has another claim to fame. It is where the last wolf in England was hunted down and killed in 1390. Legend says that the last wolf of England had been tracked to Coniston Falls and chased down south to Humphrey Head, attacking sheep and cattle on the way, by John Harrington, whose father was a Sir. He then slayed the wolf on Humphrey Head. Another version of the legend is that the wolf had attacked and killed a young boy in the village of Cark before attacking the local flocks of sheep. The wolf was then chased up Humphrey Head before falling over the cliff edge to the rocks below. The wolf was trapped due to its injuries and the locals killed it using pikes. Which story is right, I don't know. However, I do know of the ghost stories of a wolf that wanders around Humphrey Head and when walkers spot it, the wolf runs and then fades into the trees like mist. There are also similar reports on the rocks below. And if it is a full moon on the same day of its death, a wolf can be seen and heard howling at the sky. The other ghost stories I have been told concern on the ground around the base of Humphrey Head where the path circles around the headland. Walkers have spotted a young boy in the middle of the path. He is said to be dressed in Victorian clothing complete with cap and shorts, and what stops people in their tracks is how white the boy's face is. One person told me it was so white it was almost glowing and due to the fact he was so white they just knew he was dead. The boy then turns and runs away, not to be seen again. Sadly, this may be the ghost of William Pedder, who in 1857, aged only ten, fell to his death while climbing the cliffs. There is a small memorial rock where the tragedy happened.

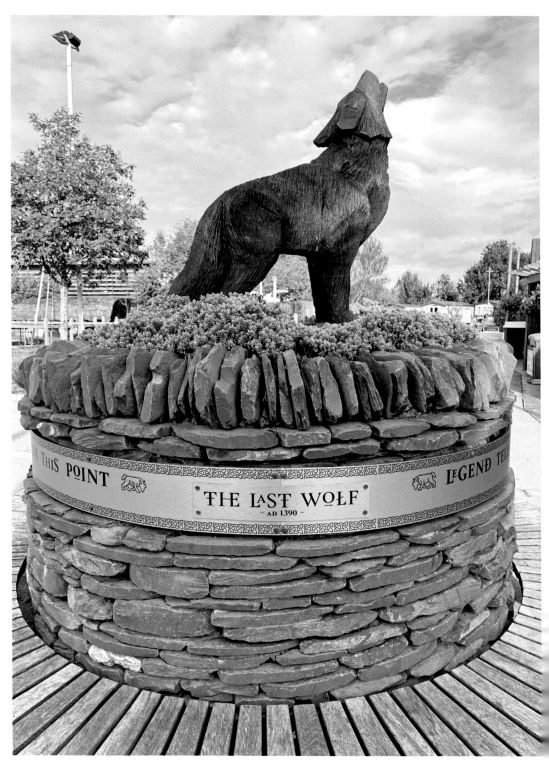

The Last Wolf monument.

Humphrey Head.

The Holy Well.

The Crown Inn, Flookburgh

Flookburgh is a small fishing village on the south coast of Cumbria and has its own version of the age-old question of 'what came first?' The Flookburgh version is what came first, the village or the fish? A fluke is a flat fish that is caught in the bay that the village overlooks. The general consensus is that the village and the name of the fish are unconnected. The settlement dates back to eleventh century and has always been recognised as an important fishing village. Over the next 500 years, nothing of note seemed to happen in the village as it probably just continued with its fishing and had a farm estate on the outskirts. The Second World War would see a huge influx of visitors to Flookburgh as the RAF built the Cart Airfield on its southern outskirts. The airfield had military aeroplanes arriving and leaving all day, every day and also housed anti-aircraft guns. The base was closed in 1945 and used as a private airstrip.

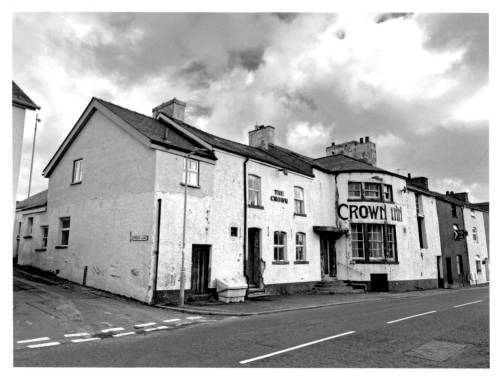

The Crown Inn.

The building that I have been told several ghost stories about is The Crown Inn. The inn is still standing on Market Street in the centre of the village. Although it is currently empty, it still is a large, imposing and, I must say, spooky building.

When The Crown Inn was built is still a bit of a mystery; it shows up on a map dated 1685 but does not reappear until the start of the nineteenth century. During that century, the inn changed hands many times and had numerous uses. It was where several land auctions took place, drowned bodies had been conveyed to the inn after the unfortunates drowned trying to cross the sands and we also have a report of an unsolved assault connected to the building.

I was told about a series of events that were said to have taken place in the 1960s or 1970s. The staff would report feeling very uncomfortable in the cellar. Already a cold area, staff said that the temperature would drop quickly to the point that you could see your breath, which would be followed by the barrels of beer falling over or bottles falling off shelves. In the bar area, furniture would move by itself. Tables would tip over, soaking the laps of the customers, often leading to arguments as the customers would blame each other. One member of staff said this would happen on a regular basis to the point that they thought they were getting pranked. They said the upstairs was worse; they dreaded having to walk upstairs. It was always dark and felt like someone was watching and waiting for you to come up, but no one was there. Although they really enjoyed their time working in The Crown Inn, they said it was probably the most eerie place they had ever been and they never switched all the lights off as the thought of being there in total darkness was terrifying.

I can't find a lot of information about the inn or the village that would identify who or what would cause this activity. I was told about similar activity, but not as intense, by someone who worked there at a later date.

Flookburgh.

Morecambe Bay.

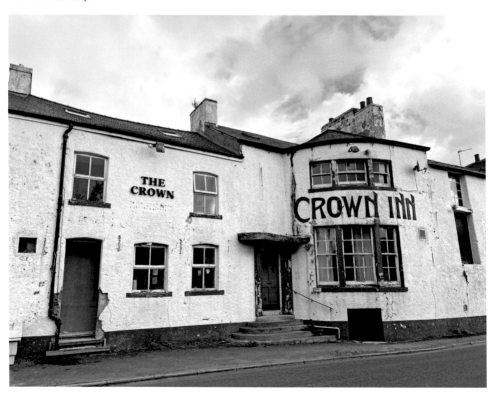

The Crown Inn with over 300 years of history.

Coniston Water and Village

Nestled beneath 'The Old Man', you will find the small village of Coniston and its lake with the same name. The Old Man is the mountain that overshadows the area and is a favourite peak for walkers to climb. As with many place names in Cumbria, it is believed that the name Coniston derives from Norse and suggests that there was a Viking settlement nearby. The village is mentioned in the twelfth century but does not get mentioned again until the late 1500s when Queen Elizabeth I granted permission for mining to take place as the mountain was full of copper ore. A small industry then followed for smelting using the local resources of copper and charcoal. From 1760 onwards, Britain would experience the Industrial Revolution and the Coniston copper mine became one of the biggest in the world. In 1914, after 150 years of large-scale mining, the copper mine closed.

During the Victorian era, the village would thrive, as did many of the villages and towns of The Lakes. Taking full advantage of the 'new' tourism, this trade would slowly improve with the introduction of the railway and was also highlighted in the works of John Ruskin. John was a very popular writer and poet and would be very successful during the latter years of Queen Victoria's reign. His popularity and connections were such that he was offered a burial at Westminster Abbey. However, before his death he had made it clear that he wanted to remain in Coniston and was laid to rest in the village church of St Andrew's. During his later years, Ruskin bought the manor house called Brantwood, which had been built in eighteenth century and is now open to the public as a museum.

Today, Coniston village and its large lake still enjoy the successes of the tourist trade with it welcoming its fair share of the 18 million visitors that arrive at the Lake District each year. However, I can't finish writing about the history of Coniston without mentioning the late, great Donald Campbell, who sadly lost his life on Coniston Water on 4 January 1967. 'The Skipper' set several water and land speed world records but sadly lost his life when his craft *Bluebird* flipped at high speeds. Unfortunately, neither the boat nor Donald survived. Donald had been a hero to many for his stuntman efforts and, surprisingly, he had an interest in the paranormal as he was a member of the renowned 'Ghost Club' in London, and it is said that he had a premonition of his death the night before the tragedy.

Coniston does seem to be a hub of paranormal activity of all different kinds. We have stories of fairies, imps, daemons, and the devil himself. Coniston Water has its own 'Lady of the Lake' and a very impressive photograph of a UFO. In 1954, a Coniston schoolboy called Stephen Darbishire took a photograph of what can only be described as an alien spacecraft flying over the village. The clear and vivid image

gained worldwide recognition and the media became very interested. However, this is where the story takes a turn and what happens next will depend on your own opinion. The original photographs and negatives were stolen from Stephen. He was then allegedly visited by some very important and high-up officials, one of whom was said to be the personal secretary of Prince Philip. Soon after, Stephen admitted it was all a hoax, although many people believed he was pressured into releasing this statement. Over the years, Stephen refused to discuss the matter any further.

A recurring ghost story around Coniston concerns the sightings around Simons Nick up on the side of the Old Man. Simons Nick is a cave-like entrance and can be seen above Coniston village. I have been told many stories of a man seen running out of the entrance before disappearing into thin air. Some stories say the man stands at the entrance waving people away in a panic before disappearing into the mine. This could be the sighting of the man who gave the place its name. As legend has it many years ago there was a poor miner from Coniston called Simon who was having no luck finding the copper that the mountain was famous for. As his funds dwindled, so did his luck. Then one evening he was visited at his campfire by some fairies, though some say it was daemons or the devil, and he struck a deal. They would show him exactly where to mine but he could never reveal his secret, or he would suffer serious consequences. Simon kept his word for many a year and became rich and successful. However, it brought envy from many people across Cumbria. Unfortunately, one night while in a tavern in the village, Simon had a few too many, plied to him by some unscrupulous folk, and he finally told the story of the fairies. Obviously the locals laughed him out of the tavern and mocked him for his drunkeness. Simon's luck changed overnight as the fairies had promised and it is said that he visited his mine and accidentally blew himself up with a barrel of gunpower, leaving his rich mining seam sealed and closed forever. So, could this ghostly apparition be Simon? Whatever you believe, I would not make any deals with any fairies you encounter up on the side of the Old Man of Coniston.

A day trip on the boat.

Another part of village that has been mentioned several times is The Black Bull Inn. One of the oldest coaching inns in Cumbria, if not the country, The Black Bull was built during the 1600s and welcomed travellers from coachmen with their horses to modern-day visitors. With it being so old, it may have even been where poor Simon shared his secrets.

It is easy to spot the large white building in the village and inside you will be transported back in time as all the original features can still be seen. I do have to say that none of the stories that have been told to me have reported any angry or bad ghosts – a lot of the sightings seem to be of people from days gone by.

One report was from a man and woman who had been visiting Coniston on holiday. They had decided to go to the pub for a drink as it was a warm summer's evening. As they walked around the pub to the entrance, they watched a man dressed like what they described as 'an old-fashioned horseman' tying up his horse at the back. They said he was dressed in tight breeches, long black shiny boots, a smart blue jacket, and a black pointed hat. The man said the horseman had tipped his hat in their direction as he entered the pub. The couple laughed between themselves, wondering if the horseman was an actor or a member from a historic society either working in the pub or one of the local attractions. When they entered the pub, they looked around and the man couldn't be seen. They went to the bar to order their drinks and asked the barman where the horseman was. The barman stared back at them blankly and asked who they were talking about. The couple explained what they had seen, and the barman stood and shook his head and said no one of that description had come into the bar. By now the couple were perplexed and looking at each other in disbelief. The man got onto his phone and started to google horsemen and identified the clothing worn as being from the Georgian era. He showed the barman, but again the barman said no one had entered the bar dressed like that. The man explained he had seen the person tie up his horse outside. By now the barman was laughing nervously, so the couple went outside only to find there was no horse. Needless to say, they couldn't face going back into the pub. However, the couple have said it was a holiday adventure they would never forget.

Coniston village.

The Coniston Steamer.

Up on the Fells.

The fourteenth-century church.

Could the ghost house be up in hills?

Acknowledgements

As always, thank you for reading my book and to all the people that have told me their many stories over the years. Thanks to Peter Woolford as the photographs in the chapters on Wray Castle, Grasmere and Coniston are used with his kind permission. Thank you also to D. Taylor as the photographs for the chapter on Long Meg and Her Daughters are used with her kind permission. Finally, thanks to all the Ghosties out there that support myself and the GHOSTnortheast team.

Books available by Steve Watson:
The Chronicles of a Ghost Hunter: Volume One
Paranormal Newcastle
Paranormal Sunderland
Paranormal Middlesbrough and Teesside